IMAGES
of America
MADISON COUNTY

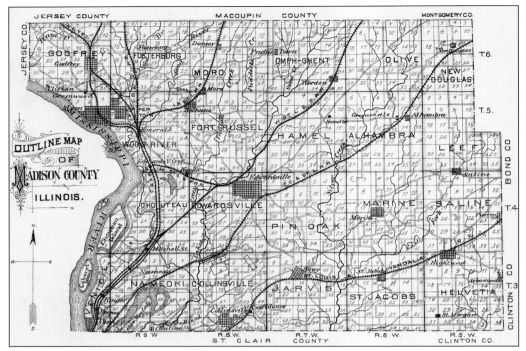

This 1882 map of Madison County shows the growth of communities, roads, and railroads in the 70 years since it was established. The railroads connected the communities to each other and to the markets for goods and services. Today, many of these railroad beds are bicycling and walking trails for recreation and transportation. (Courtesy of the Madison County Historical Society Inc.)

ON THE COVER: The German Evangelische Salems Gemeinde at the Silver Creek and near Greencastle was established in 1860. Today, it is known as the Salem United Church of Christ in Alhambra. By 1869, the congregation had moved a mile south and built a new church, seen in this image in the center. This photograph was taken during a mission festival in 1892 or 1893. (Courtesy of Salem United Church of Christ.)

IMAGES
of America
MADISON COUNTY

Mary T. Westerhold
and the Madison County Historical Society

ARCADIA
PUBLISHING

Published by Arcadia Publishing
Charleston, South Carolina

Printed in the United States of America

Library of Congress Control Number: 2012954811

For all general information, please contact Arcadia Publishing:
Telephone 843-853-2070
Fax 843-853-0044
E-mail sales@arcadiapublishing.com
For customer service and orders:
Toll-Free 1-888-313-2665

Visit us on the Internet at www.arcadiapublishing.com

*To Sharon Helms, whose dedication to the Madison
County Historical Society inspired many others.*

CONTENTS

ACKNOWLEDGMENTS

This book could not have been created without the help of so many others. I wish to thank all Madison County Historical Society board members, staff, and volunteers for their assistance and encouragement during this project; John Celuch and Jeff Wehling for their thoughts and assistance while working together to create the bicentennial exhibit, which inspired this book; Cheryl Jett and Cindy Reinhardt, who offered their expertise and encouragement; and Amy Perryman, my editor, for her patience and guidance.

I also wish to thank my daughter, Jessica, for her patience, understanding, and support while I was working on this book.

Unless otherwise noted, all photographs are courtesy of the Madison County Historical Society Inc.

INTRODUCTION

It was September 1812 and Madison County had just been created by proclamation of territorial governor Ninian Edwards. The county was sparsely populated, with an estimated population of less than 3,000. Many of the residents at that time lived on farms and in settlements near rivers and creeks. The threat of attacks from Indians, incited by the British during the War of 1812, was on the minds of these settlers who had built blockhouses and forts to protect themselves and their families during difficult times. It was an inauspicious beginning for the new county.

The settlement of Madison County began many years before 1812. Indians had been in the area for centuries, especially in the region surrounding Cahokia Mounds in Nameoki Township. Other tribes had used the area for hunting. The French were the first Europeans to visit the area and record their arrival through the journals of Fr. Jacques Marquette and Louis Joliet, documenting their travels down the Mississippi in 1673. Permanent settlements came much later, with a few French families settling on Chouteau Island by 1750 and planting an orchard.

Rev. David Badgley, a Baptist preacher, visited the county in 1799 and, noting the lush vegetation, named the area Goshen after the fertile Biblical land of Goshen. While Badgley's visit was brief, the name Goshen was used for many years to refer to a large area of Madison County and a road that passed through it.

According to W.R. Brink's 1882 *History of Madison County*, Ephraim O'Conner became the first American settler when he built a rough cabin in 1800 in the northwest corner of Collinsville Township. However, by 1801, he was ready to move west and sold his land and cabin to Samuel Judy, who became a permanent settler and built the first brick house in the county in 1808.

After the Monks of La Trappe settled on the largest mound in Cahokia Mounds in 1807, it was known as Monks Mound. The monks are also credited with being the first to discover coal in Madison County when they found it in the nearby bluffs. Their settlement did not last long because sickness took a heavy toll on their ranks.

After the War of 1812, settlers began arriving in larger numbers since many felt the threats from Indians and the British had ended. By 1820, the population had swelled to 13,550. A few of the names found in the early records of the county are Aldrich, Armstrong, Atkins, Deck, Duncan, Ferguson, Flagg, Gillham, Jarvis, Judy, Lusk, Montgomery, Moore, Newman, Paddock, Pearce, and Whiteside.

Many of the early settlers were farmers, and the need for mills and transportation soon arose. Mills were first built near creeks and rivers since water was used to power them. Steam-powered mills came next. Waterways were also important for transportation until better roads and railroads were created. If a railroad came through a town, the chance of survival and growth of that town increased because of the reliable transportation provided by the railroads.

There was more to life than agriculture in Madison County. General stores were needed to supply the goods that could not be produced locally and also to provide a meeting place to learn the latest news of the area. Doctors were needed to fight sicknesses and heal injuries. Other

businesses and professions included dentists, lawyers, carpenters, hotel and tavern keepers, harness and saddle makers, blacksmiths, and newspapermen.

Many early settlers came to Madison County for a chance at a better life for themselves and their children. To that end, the residents were quick to establish schools. The first school on record was the Casterline School in Collinsville Township, established in 1804 or 1805 with James Bradbury as the teacher. School was held near Edwardsville in 1809, but there is no record of the teachers there. The St. Jacob Township settlers kept a school going while they were gathered in a fort during 1812 and 1813, and when peace had been arranged, erected a cabin for use as a school in 1817. By 1832, when the county was just two decades old, nearly every township had at least one school. Joshua Atwater taught at several early schools in the county, traveling from town to town and encouraging education. In 1837, the city of Alton was the first in Madison County to pass a charter to create free schools. By 1882, the county had 136 schoolhouses.

Education did not stop at eighth grade. Rev. John Mason Peck established Alton Seminary in Upper Alton in 1832. The name was changed to Shurtleff College in 1836. Monticello Female Seminary, located in the town of Godfrey, was established in 1838 by Benjamin Godfrey and continued until 1971. In 1879, Edward Wyman established the Wyman Institute as a boarding school for boys. It would become Western Military Academy, which operated until 1971.

Churches were another mainstay of life. The first religious services were held in homes; circuit riders who rode from town to town provided the preaching. The first Methodist church was built a few miles south of Edwardsville in 1805. A Baptist church was organized at Wood River in 1807. In Edwardsville, a Presbyterian church was formed in 1819. In Alton, 14 Roman Catholic families held services in a frame building owned by one of the members, with Fr. George Hamilton presiding. These are only a few of the early congregations. Many more existed and are too numerous to mention.

The early settlers came to Madison County for many reasons. Some stayed and made permanent homes while others moved on to new settlements. By the time the photographs in this book were taken, their descendants were continuing the growth of the county. This book highlights a small part of the over-200-year history of Madison County.

One

MADISON COUNTY
BEGINNINGS

MADISON-COUNTY
1812

On September 14, 1812, Madison County was created by a proclamation issued by territorial governor Ninian Edwards. This map of Illinois highlights the extent of Madison County in 1812, covering all territory in Illinois north of the current southern boundary of Madison County and between the border with Indiana to the east and the Mississippi River to the west. Edwards named the county Madison after his friend, Pres. James Madison.

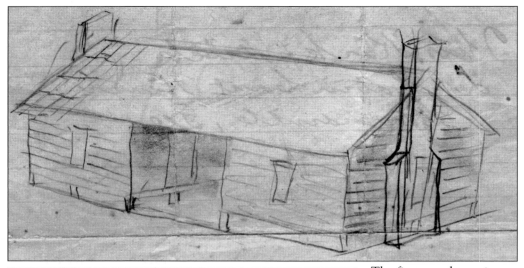

The first courthouse in Madison County was located in the home of Thomas Kirkpatrick in Edwardsville, shown in this sketch by Charles Benedict. Although a committee was formed in February 1813 to "fix the permanent seat of Justice of Madison County," a new courthouse was not completed until February 1817. It was the first of four buildings in Edwardsville designed specifically for use as a courthouse.

As the surveyors moved north in Illinois and more land was available for purchase, new counties were created and the boundaries of Madison County continued to shrink. When Illinois became a state in 1818, Madison County had been reduced to less than half its original size. By 1843, the final boundaries of Madison County, shown on this map, had been determined.

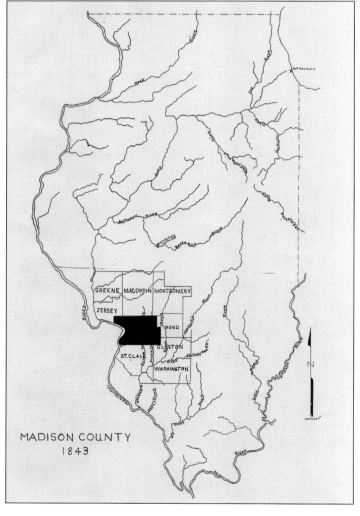

MADISON COUNTY
1843

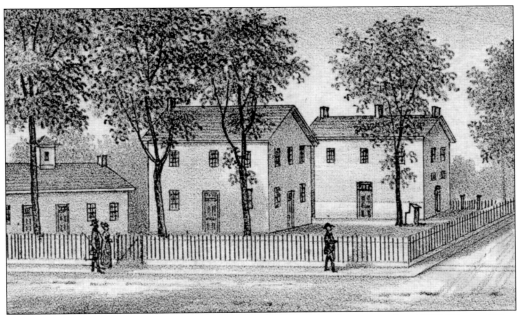

In 1821, a new courthouse was begun in Edwardsville and finally occupied in 1835. The building was known as the "donation courthouse" because the structure was started with donations of cash and materials. Although built of brick, this courthouse had dirt floors and a second story that could only be reached by a ladder. The buildings shown here include the circuit clerk's office (left), "donation courthouse" (center), and jail (right).

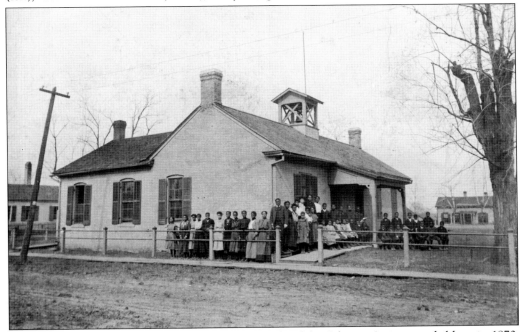

The former circuit clerk's office was opened as a school for African American children in 1870. In 1877, there were 29 students. W.E. Kelly was principal until 1889, when J.B. Bates replaced him. The first graduates were Rosie Kinchlow and Mollie Fisher. This 1910 photograph shows the school shortly before it was replaced in 1911 by a new, four-room building.

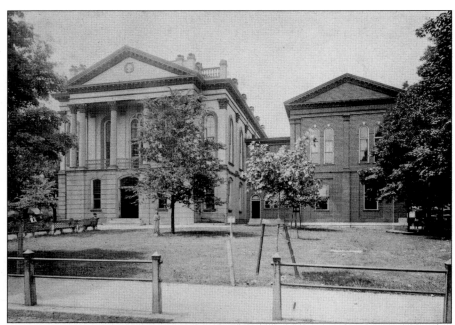

In September 1857, a two-story courthouse (above, left) was completed on the site of the present courthouse. Previously, all county buildings had been located in an area now bounded by North Main and Liberty Streets in Edwardsville. An annex (above, right) was added in 1891. By the early 1900s, discussions began on the need for a new building. However, because of intense rivalry on the part of Granite City and Alton for the county seat, the bond issues failed. It was not until the unification of the county during the centennial celebrations in 1912 that serious discussions began. On February 28, 1914, a memorial service was held for the courthouse, and buildings were razed soon afterward. After about a week, the upper floor of the annex and roof of the main building were already gone (below).

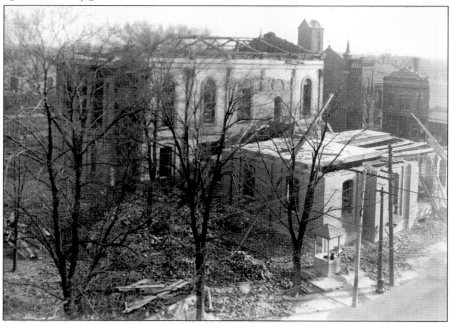

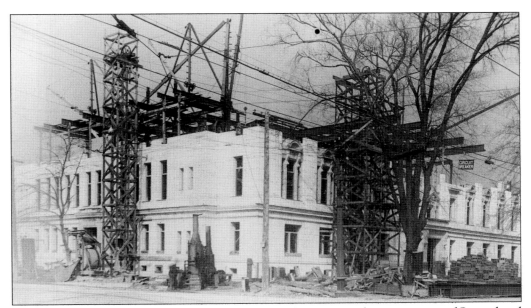

The construction of the courthouse is pictured in early 1915 near the intersection of Second and St. Louis Streets. The outer walls of the building are almost finished. The taller of the two elevator shafts, seen here, was 80 feet tall. It collapsed during the work, and two workers were injured.

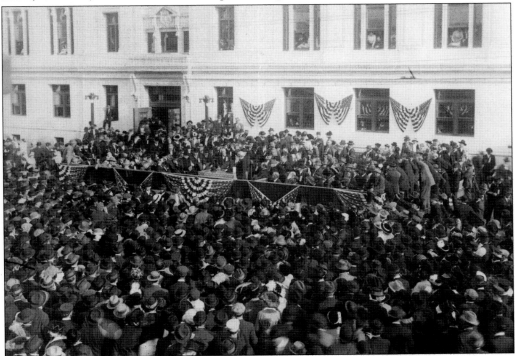

Spectators jammed Purcell Street to view the courthouse dedication on October 18, 1915, while others can be seen in the windows of the courthouse. Congressman Joseph "Uncle Joe" Cannon of Danville was the main speaker, and he shared the platform with county officials, members of the board of supervisors, and others active in the construction of the building. The final cost of the courthouse was $295,000.

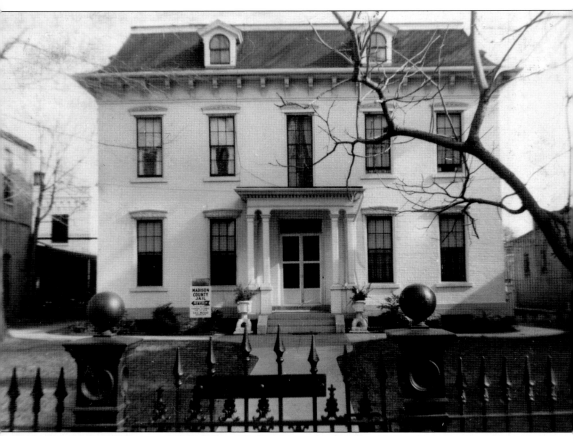

The Madison County Jail and Sheriff's Residence was built in 1869 on North Main Street across from the courthouse. The three-story brick residence was designed by architect Charles Spillman. Some of the more interesting architectural features of this Second Empire–style building included a Mansard roof, wooden cornices supported by carved brackets, and windows topped by cast iron lintels. When the 1915 courthouse was built, a tunnel was added for the transportation of prisoners between the courthouse and jail. The sheriff's residence and jail remained in use until the dedication of a new county jail in May 1980. Many county residents sought to preserve the historic buildings, but they were demolished in April 1982. Out of the preservation effort, the Goshen Preservation Alliance Inc. was born and continues its efforts today. The area where the sheriff's residence and jail once stood is now the Madison County Transit Station.

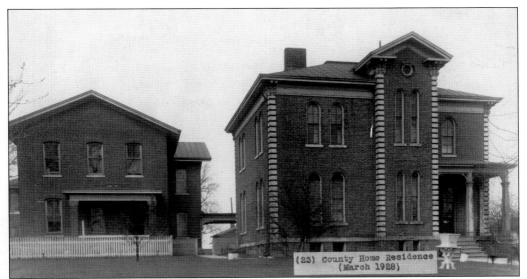

(23) County Home Residence
(March 1928)

From the earliest records of Madison County, funds have been expended for the care of the poor. In the 1860s, buildings were erected on acreage in Edwardsville for housing the poor. It was an operating farm for many years, and residents were expected to help with the farm work. The facility closed in the 1950s and became a nursing home and later Madison County Shelter Care.

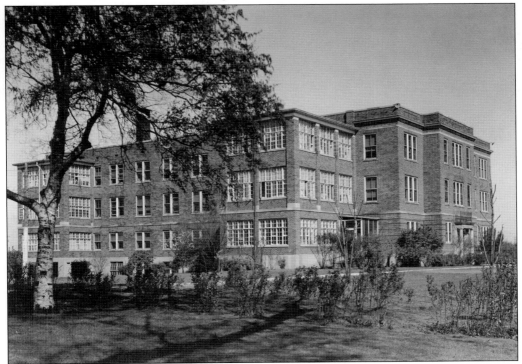

The Madison County Tuberculosis Sanatorium opened in June 1928 for the free treatment of county citizens. The complex, located on Troy Road in Edwardsville, included a combination administration building and medical director's home and a separate nurses' residence. Later it was used as the Madison County Nursing Home before closing in 1999. The buildings were razed in 2005, and the area is now the Edwardsville Crossing shopping center.

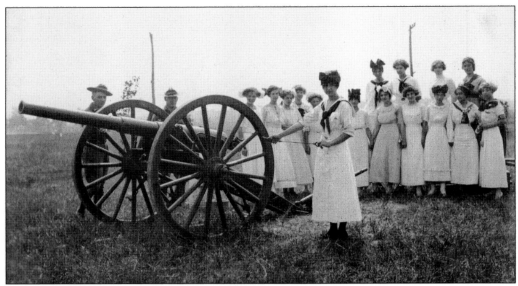

Madison County celebrated its centennial in grand style in an eight-day celebration from September 14 to 21, 1912. At 10:00 a.m. on Saturday, September 14, whistles shrieked and church bells rang in Edwardsville. Ten minutes later, the first of 100 cannon shots was fired. Eleanor Boeschenstein is shown above preparing to fire the first shot. Eleanor was the daughter of Charles Boeschenstein, the president of the Madison County Centennial Association. On Sunday, a flag was raised (below) at the presumed site of Fort Russell and a plaque was attached to the flagpole that read: "1812–Fort Russell. Erected by Pioneer Descendants, September 14, 1912." The flagpole and plaque have both since disappeared.

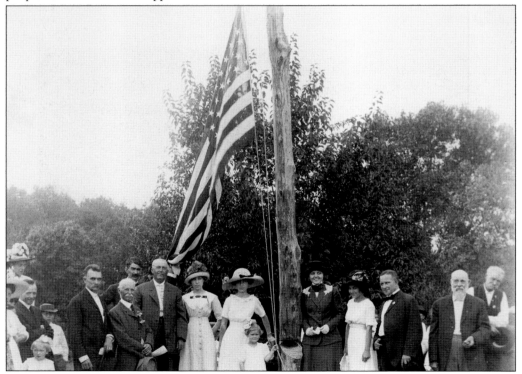

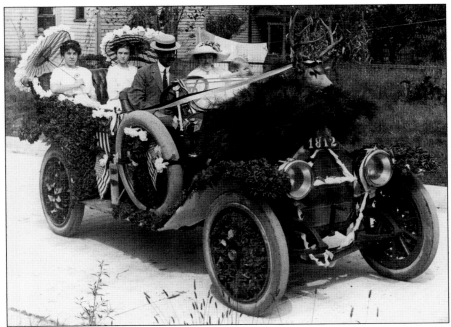

The centennial celebration continued on Monday, September 16, with the arrival of Gov. Charles S. Deneen, justices of the Supreme Court of Illinois, and other state officials. The day's program began with a parade of 75 decorated automobiles in Edwardsville. The automobile above is occupied by the family of attorney Thomas Williamson. From left to right are Bessie, Jessie, Thomas, Martha, and Robert. The decorations included white and green bunting, red flowers, flags, and red and white shields. A deer head and boughs of trees and shrubs completed the rustic appearance. Shown below is the automobile owned by Ralph C. Wayne and decorated with pink and white bunting and white roses and butterflies. From left to right are Caroline Wolf, Paul Schwarz, Charles O. Nash, and Fanny Nash.

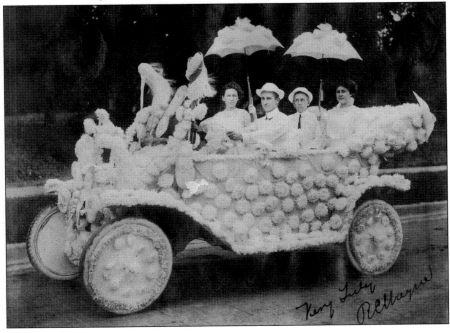

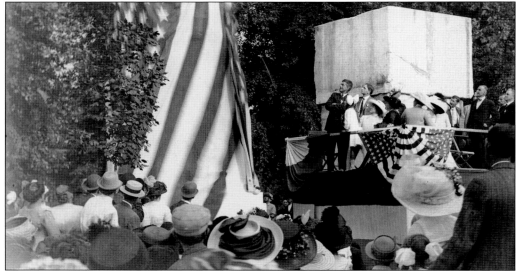

Monday's events moved to the Edwardsville City Park for the unveiling of the model of the centennial monument. Young Mary Elizabeth Edwards, descendant of Gov. Ninian Edwards, pulled the cord to release the flags and uncover the model. Charles Mulligan, designer of the monument, is shown on the platform to the right with his arms folded. The model was used by sculptors to create the monument from the block of marble shown above. The completed monument is shown below. As part of the celebration of the bicentennial of Madison County in 2012, the city of Edwardsville and Madison County jointly sponsored the restoration of the monument.

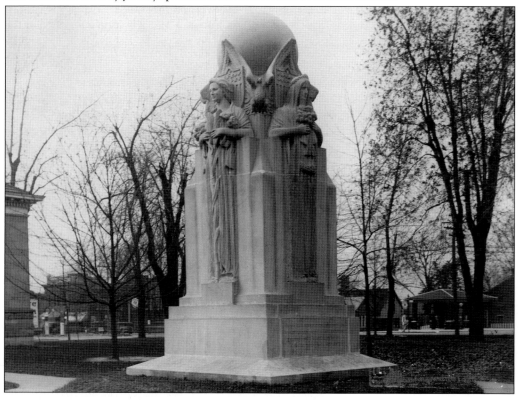

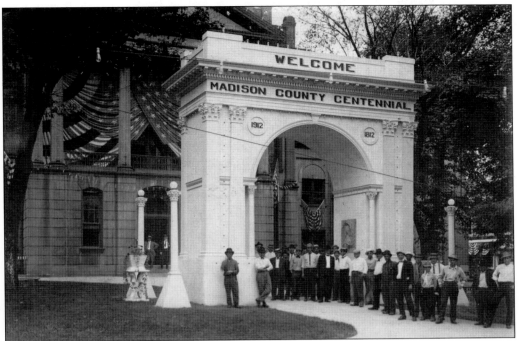

The Monday of the centennial celebration also marked 100 years since the establishment of the courts in Madison County. A grand arch was designed by architect Michael B. Kane and erected in front of the courthouse. It was made of plaster of paris and included two large medallions representing Gov. Ninian Edwards and Gov. Charles Deneen. The celebration continued in the courthouse as a plaque was dedicated to Revolutionary War soldiers buried in Madison County. The courtroom shown below was decorated with flowers, potted plants, and flags for the occasion. The officials are, from left to right, chief deputy county clerk Emma Mackinaw, county clerk Harry J. Mackinaw, county judge John E. Hillskotter, and chief deputy sheriff Thomas C. Dooner.

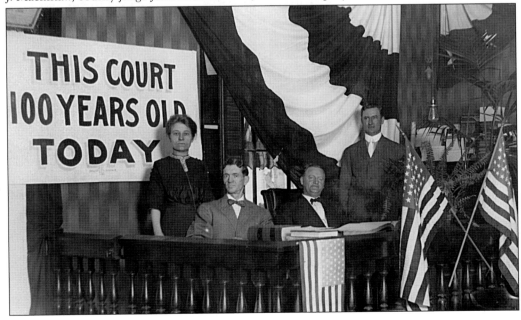

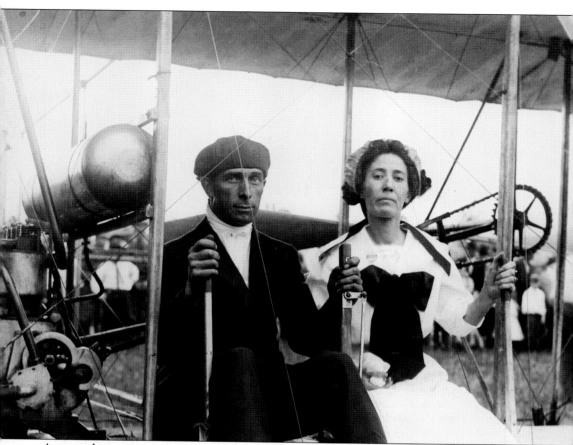

Among the more interesting activities of the centennial celebration was the opportunity for "aeroplane" rides. Mary Lusk became the first woman in Madison County to fly in an airplane. She is shown here with pilot Eugne Heth just prior to takeoff. Her determined expression leaves no doubt that she will complete the ride. However, she was not the only adventurous Madison County resident. Others who enjoyed the opportunity that same day were Georgia Lusk, Viola Gueltig Gamble, Katherine Lanham, E.L. Lax, P.P. Lusk, Joseph A. Barnett, E.L. Witherell, and Charles Gueltig. Other festivities during the eight-day celebration included a parade by Collinsville residents where every marcher carried a small bell, a parade by Granite City residents with marchers tossing small granite pans into the crowd, and a parade on Friday evening of the Monks of Cahokia, said to rival the Veiled Prophet parade of St. Louis.

Two

ALTON AND GODFREY TOWNSHIPS

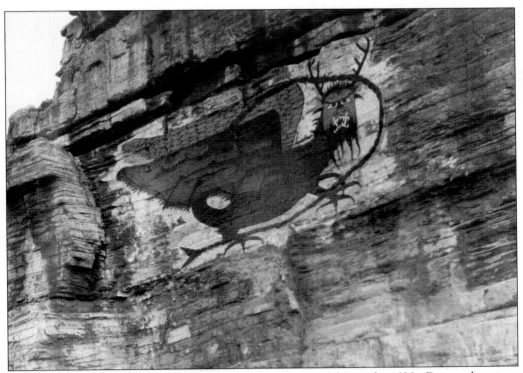

Fr. Jacques Marquette kept a journal of his travels with Louis Joliet in the 1600s. During that time, he recorded a description of the piasa bird painted on the cliffs near the current city of Alton. According to legend, the creature terrorized the Indians in the area until their chief, Ouatoga, offered himself as bait in a plan that succeeded in killing the bird. This reproduction was painted on the cliffs in 1924.

Rev. John Mason Peck established Rock Springs Seminary in 1927 near Belleville. The campus moved to Upper Alton in 1832 and the name was changed to Alton Seminary. Loomis Hall, pictured here, housed the entire facility. In 1836, the name was changed to Shurtleff College, after a generous donation by Dr. Benjamin Shurtleff of Boston. It closed in 1957. The Alton Museum of History and Art now occupies Loomis Hall.

In 1879, Edward Wyman opened a boarding school for boys in Upper Alton. After Wyman's death in 1888, the school's name was changed to Western Military Academy, and military training was added. Albert M. Jackson and George D. Eaton purchased Western Military Academy in 1896. The school continued with the Jackson family as owners until it closed in 1971.

Built in 1874, the Mason School in Godfrey Township was the third school in the district. The school employed excellent teachers who went beyond the basics taught in most schools of the time. Charles Deneen, who would become governor of Illinois and a US senator, taught here in 1883 and 1884. In addition to teaching, he also organized a literary and debating society.

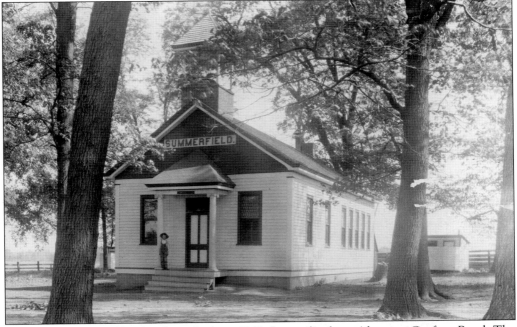

The first Summerfield School was built in 1847, four miles from Alton on Grafton Road. The first teacher was Virginia Corbett, and no school term was missed between 1847 and 1912. The most famous teacher was Lucy Larcom, who taught in the early 1850s and later earned national recognition for her poetry. In 1936, a two-room schoolhouse was built and was used until it closed in 1958.

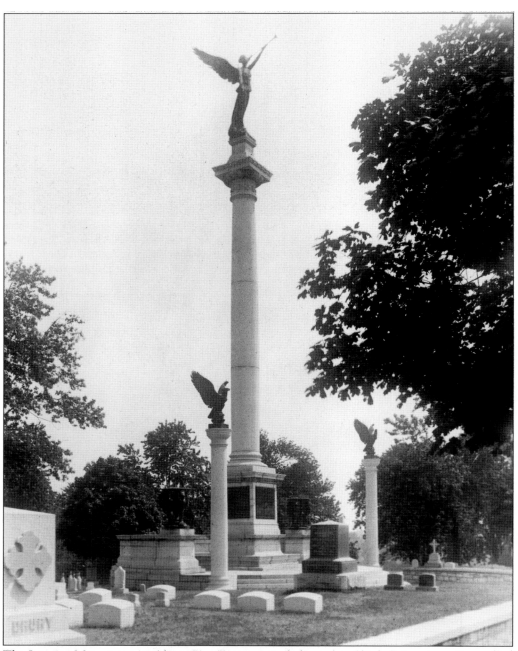

The Lovejoy Monument in Alton City Cemetery is dedicated to Elijah P. Lovejoy, often called a martyr for freedom. Lovejoy was born in Maine and moved to St. Louis as a teacher in the late 1820s. There he published a newspaper, the *St. Louis Observer*, and began advocating the abolition of slavery. After witnessing brutality against slaves, he became even more outspoken against slavery, angering many. In July 1836, his printing press was destroyed. He moved to Alton to continue his work for freedom of speech, freedom of the press, and freedom for slaves and began publishing the *Alton Observer*. After three printing presses had been destroyed, Lovejoy and 20 followers were guarding a new press in the warehouse of Godfrey and Gilman on November 7, 1837, when a mob attacked, and Lovejoy was shot and killed.

The Alton Penitentiary, opened in 1833, was the first in Illinois. The original 24 cells were expanded to 256 by 1857, but the prison was desperately overcrowded. The Alton facility closed in 1859 after the prisoners were moved to the new Illinois Penitentiary in Joliet. In 1862, it was reopened as a military prison for Confederate prisoners of war. Most of the buildings were razed shortly after the Civil War.

The Confederate monument in Alton was erected in the cemetery containing the graves of about 1,400 Confederate prisoners who died in Alton. The base of the monument includes brass plates with the names, companies, and regiments of the soldiers. The cemetery had been neglected for years, but the monument was finally completed in 1910 through the efforts of the Sam Davis chapter of the Daughters of the Confederacy.

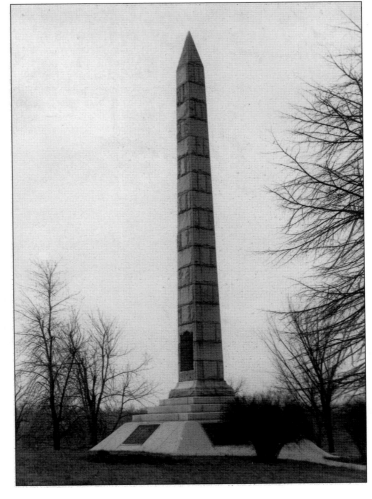

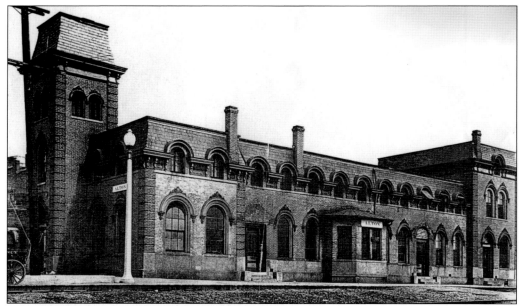

The Alton Union Depot was built in 1866 by the Chicago and Alton and the Big Four Railroads and resembled a locomotive. Located in downtown Alton, it served all the major railroad lines in the Alton area and included a hotel, baggage station, and ticket office. This architecturally unique depot was razed in 1956.

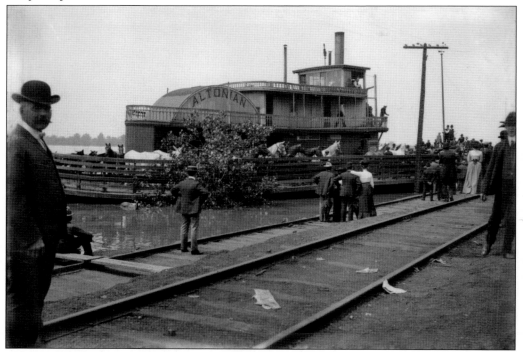

The *Altonian* ferry operated between the Alton levee and the Missouri side of the Mississippi River from 1881 until 1907. It was capable of carrying 52 teams of horses and wagons along with passengers, livestock, mail, and other freight. This c. 1903 photograph was taken before the hull was condemned in 1907. (Courtesy of Harold Meisenheimer.)

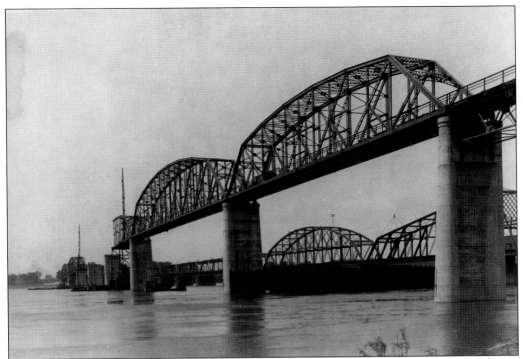

This image of the old Clark Bridge at Alton was taken when the bridge was nearing completion in the spring of 1928. The bridge opened to traffic in September of that year and served the area for many years. Designs for a new cable bridge were started in 1985, and construction began in 1990. The new Clark Bridge was completed in 1994, and the old one was destroyed.

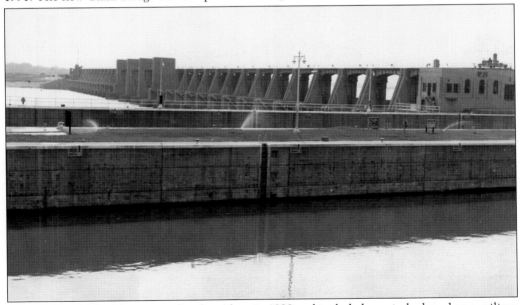

Lock and Dam No. 26 was completed at Alton in 1938 and included a main lock and an auxiliary lock. As river traffic increased, the need for an improved lock and dam became evident. This structure was replaced by Lock and Dam No. 26R, the Melvin Price Lock and Dam, located downstream from the original and completed in 1994.

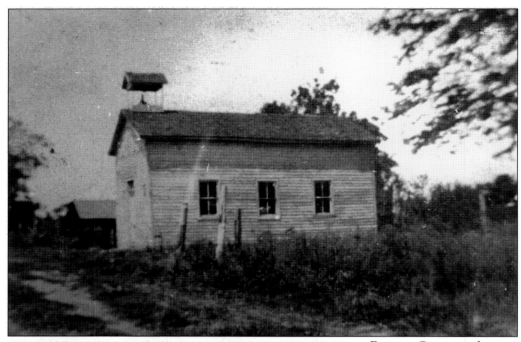

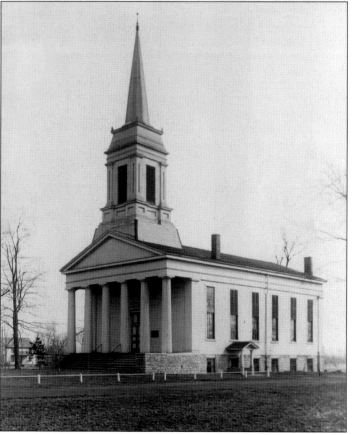

Erasmus Green was born the son of a slave woman and Reverend Green. From 1863 to 1865, he served in the Civil War in the US Colored Infantry. He returned to Rocky Fork to farm. Together with Andrew Hindman, he built the Rocky Fork AME Church (above) near Godfrey in 1869. (Courtesy of Charlotte Johnson.)

Built in 1851, the Benjamin Godfrey Memorial Chapel was a joint effort between the Monticello Female Seminary and the Congregational Church. In 1991, the chapel was moved from its original location across Highway 67 to its current site on the Lewis & Clark Community College campus, the former Monticello Female Seminary.

The Upper Alton Presbyterian Church was formally organized on January 8, 1837. Elijah P. Lovejoy served as the first pastor from January 8 until his death on November 7, 1837. The original church building burned in 1858, and this structure was completed in 1865. It was razed when the current building was constructed in 1927. The congregation officially adopted the name College Avenue Presbyterian Church in October 1925.

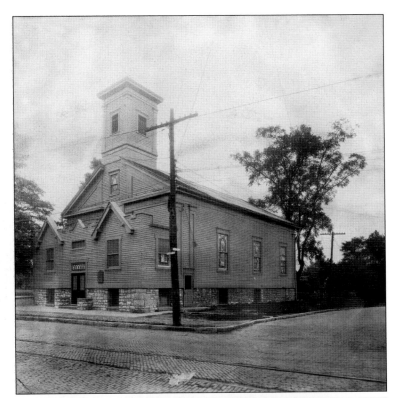

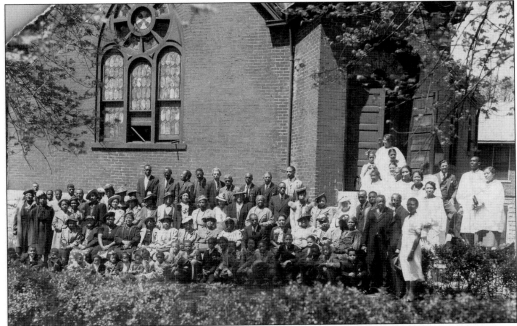

The Union Baptist Church was formed in 1837 for former slaves with the help of First Baptist Church in Alton. The members were craftsmen and domestic workers who had won their freedom. Initially, it was called African Baptist Church but changed its name (1853–1854) when its first building was constructed at Seventh and George Streets in Alton. (Courtesy of Charlotte Johnson.)

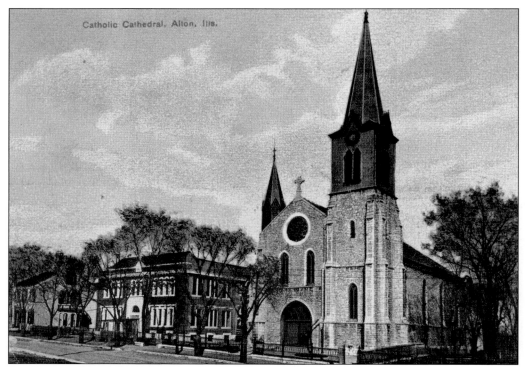

Catholic Cathedral, Alton, Ills.

Sts. Peter and Paul Catholic Church on State Street in Alton was built in 1855 out of native limestone. The church was made the see of the second Roman Catholic diocese in Illinois in 1857, and Rev. Henry D. Jungker was named the first bishop. Bishop Jungker and the second bishop, Most Rev. Peter J. Baltes, are buried in a crypt under the main altar of the church.

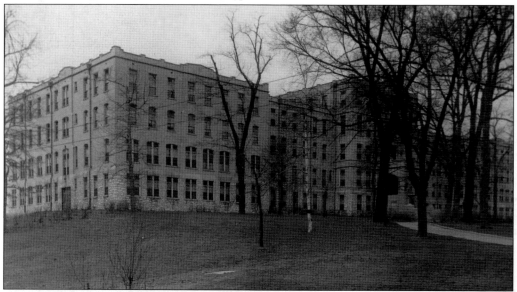

The Alton Catholic Children's Home was built in 1919 when the previous building became too small for the number of children. It was built under the direction of the Right Rev. James Ryan, bishop of the Alton Diocese. At the time of this photograph, the building could accommodate between 150 and 300 children.

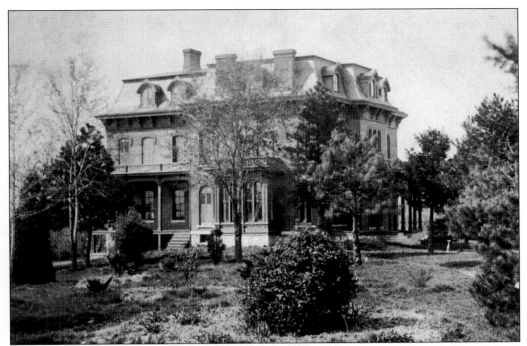

Henry Guest McPike built this mansion in 1869 on his 15-acre estate called Mount Lookout Park. It was one of the most elegant homes in Alton. McPike was a charter member of one of the oldest horticultural societies in Illinois and the propagator of the McPike grape. In addition, he was a real estate agent, fire insurance executive, and mayor of Alton.

Capt. Calvin Riley built this house in what would become the town of Godfrey in the early 1830s using native hardwoods and locally quarried limestone for the 18-inch-thick walls. Benjamin Godfrey purchased it in 1834, and he and his wife, Rebecca, made it a home for their family of eight children. The house was later owned by the Patrick Waters family for many years.

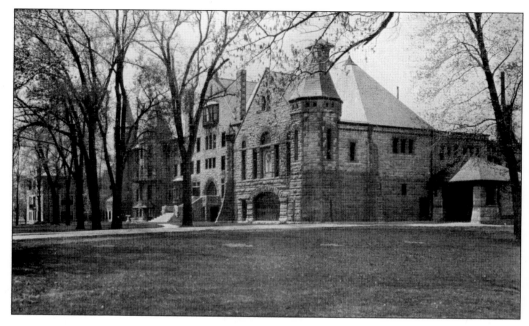

Benjamin Godfrey established Monticello Female Seminary (above). He believed that "If you educate a man, you educate an individual; if you educate a woman, you educate a family." Rev. Theron Baldwin was the first principal and classes began in 1838. One of the more well-known heads of the institution was Harriet Haskell, who served from 1867 to 1907. The 270-acre campus included many beautiful buildings such as the Evergreens (below). It was purchased by Harriet in 1890 and served as the residence of the president of the college for many years. The college closed in 1971 and the campus was purchased by Lewis & Clark Community College and continues to provide educational opportunities for many.

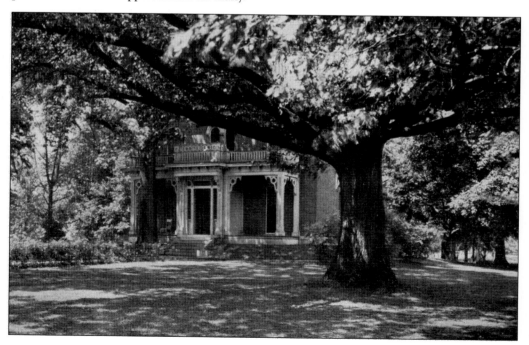

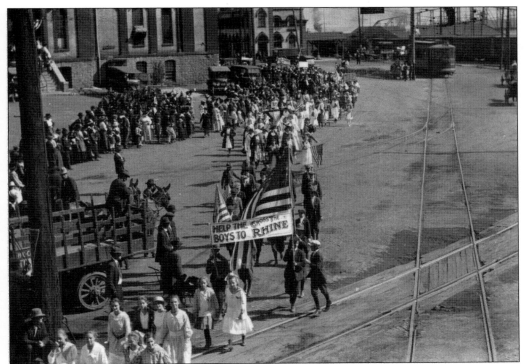

In September 1918, Alton residents gathered to watch as a Liberty Loan Parade marched through the streets. The parades were meant to encourage the purchase of Liberty Bonds to support the US effort in World War I. Liberty Loan committees were organized in every section of the country to promote the bonds with patriotic speeches at rallies, parades, and other public gatherings.

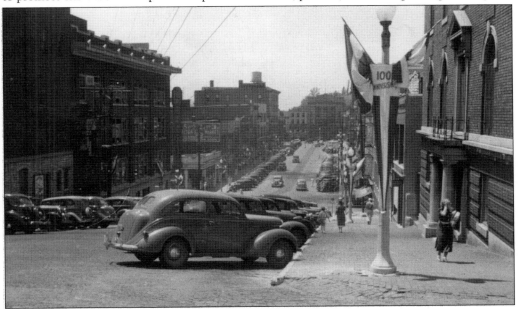

On July 16, 1937, Alton was celebrating its centennial as can be seen by the "100" banner on the light pole on Third Street. Alton was laid out by Rufus Easton and named for his son. Third Street was "downtown," where there were a variety of shops and restaurants.

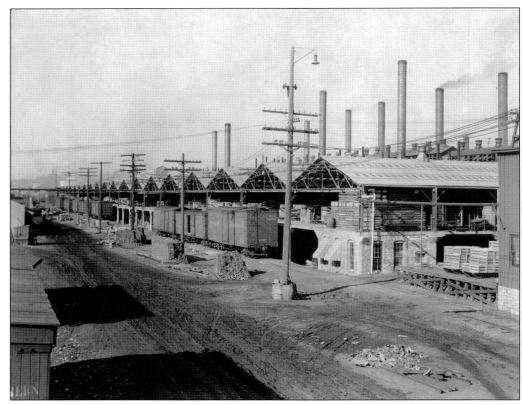

Illinois Glass Company began in 1873 as a small factory on Belle Street in Alton with 60 workers. In 1875, when owners Edward Levis and William Eliot Smith were looking to expand, the city gave them land on the riverfront, and the factory moved to Broadway. By 1927, the company was the largest producer of glass in the world.

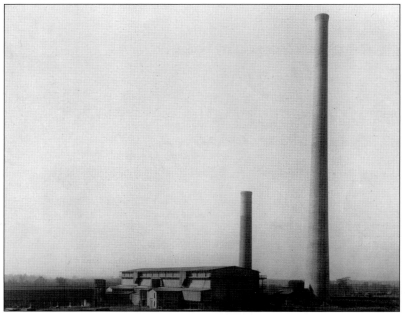

The Federal Lead Company of Alton boasted the fourth tallest smokestack in the United States in 1928. It was 450 feet high and built on an octagonal base with a diameter of 84 feet. The inside top diameter was 16 feet, and the walls were 44 inches thick. It cost approximately $200,000 to build.

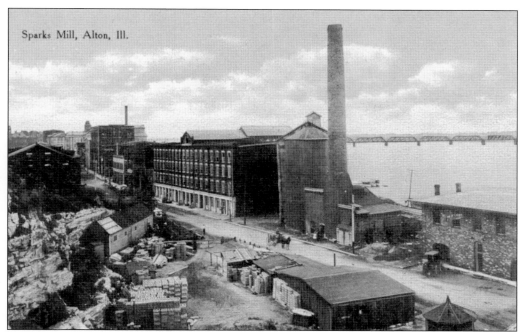

Sparks Mill, Alton, Ill.

In 1869, David R. Sparks purchased a share in a successful mill that was to become the Sparks Mill, and by 1880, he was the sole owner. The mill was known for the high quality of its products, including Arrow brand flour for breads and rolls, and Electric Light brand for cakes, pies, and pastries.

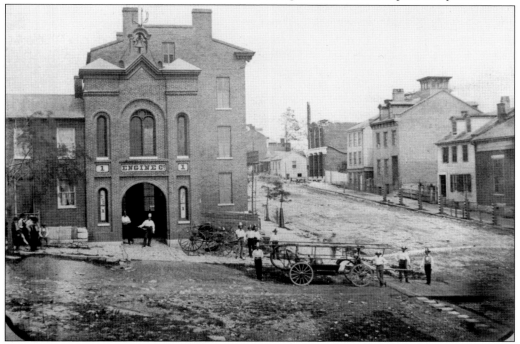

The new home of Engine Company No. 1 in Alton is pictured here in 1858. The bell at the top of the building was from the steamer *Edward Manning*. After the fire department moved to a new location, the remodeled building was used by Crivello Fruit Store and Sanders Drug Store. (Courtesy of Harold Meisenheimer.)

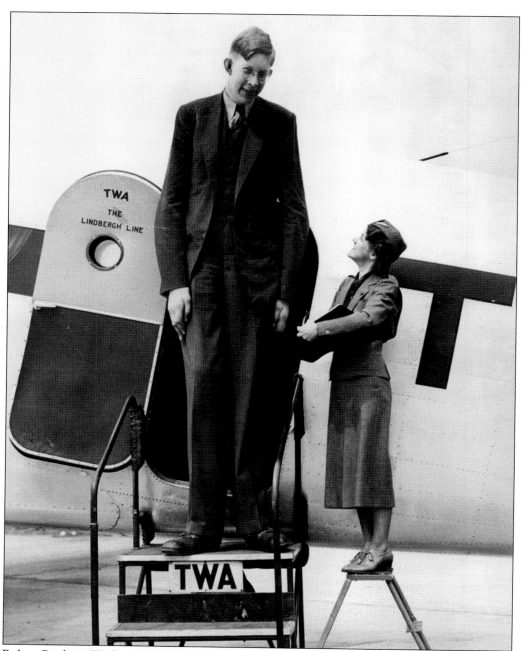

Robert Pershing Wadlow is probably the best-known Alton citizen. Reaching a height of 8 feet, 11 inches, he is the tallest man in recorded history. Although a normal size at birth, he grew at an abnormal rate, and by age five, he was five feet, seven inches tall. The growth rate was attributed to excessive secretions of the pituitary gland. His abnormal size attracted much attention, but Wadlow handled the attention cheerfully, thus earning him the nickname "Gentleman Giant." His height caused him many physical problems, and despite his efforts, it made attending college too difficult. He began to travel, making public appearances, many of them for the Peters Shoe Company, which had been making his special shoes for years. He died on July 14, 1940, at the age of 22, from an infection caused by an ill-fitting brace.

Three

FORT RUSSELL, MORO, AND FOSTER TOWNSHIPS

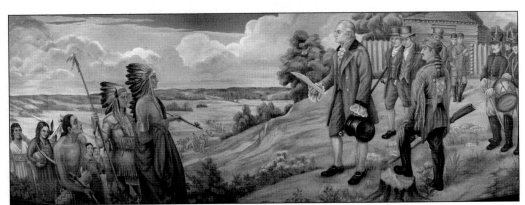

This mural was painted in 1921 by Robert Grafton, depicting the July 1819 signing of a treaty with the Kickapoo Tribe. Macine, chief of the Kickapoo, is shown here with his followers along with US government representatives Ninian Edwards, Auguste Chouteau, Benjamin Stephenson, and Jacques Matte. The mural currently hangs on the second floor of the Madison County Administration Building. (Courtesy of John Celuch.)

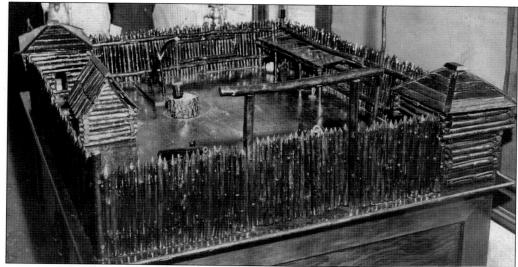

Fort Russell was named in honor of Col. William Russell, who was given command of 10 companies of rangers for the purpose of protecting the frontier during the War of 1812. Governor Edwards made Fort Russell the headquarters for military stores and munitions. This model was created by the Manual Arts Class of Wood River Elementary School in 1925 and is on exhibit at the Madison County Historical Museum.

Gaertner's Three Mile House opened to travelers along the St. Louis–Springfield stagecoach route in 1860. The building included a dining room, kitchen, tavern, grocery store, and post office, 10 to 15 bedrooms on the second floor, and a floored attic that could be used for additional sleeping quarters. In the 1880s, the business closed, and a succession of owners and uses followed until fire destroyed it in 1985.

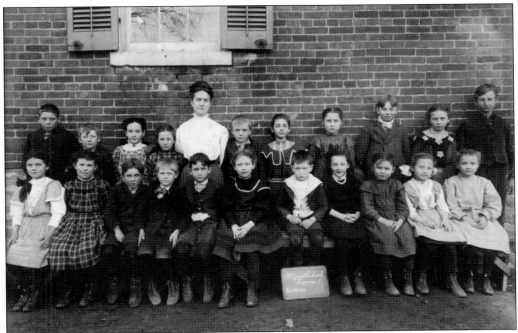

Moro School began in 1838 when residents met and organized a school district and hired Lydia Newhall as a teacher. The school was held in various locations until this brick building was built in 1880. This 1908 photograph shows the teacher and students at Moro School.

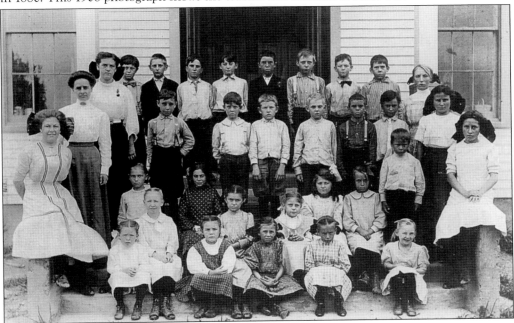

Fosterburg School was organized in 1858 and a brick and frame structure was built. Later, a one-room, frame school building was erected and eventually partitioned into two rooms. This school was completely destroyed in the tornado of 1948, and a new school was dedicated in January 1949. The students in this 1890 photograph are in front of the frame school building that was destroyed in 1948.

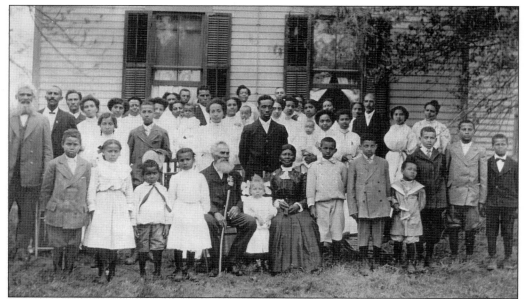

The James and Matilda Ballinger family held a reunion in Woods Station, Foster Township, in 1910. James Ballinger served in the Civil War and afterward moved to the Woods Station area and bought a farm. They lived there the rest of their lives, raising a family, and were known as good farmers and good neighbors. (Courtesy of Charlotte Johnson.)

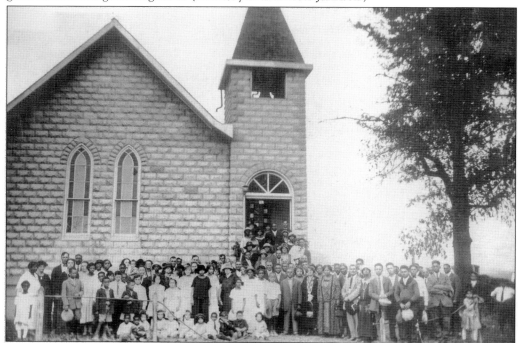

Shown here is the Salem Baptist Church congregation in 1925. The church was organized in 1845 and the first pastor was Rev. W.D. Anderson. The first building was a frame structure, followed by a brick structure in 1878. In 1912, this building replaced the 1878 church. The African American families in the area have been strongly linked to the church for many years. (Courtesy of Charlotte Johnson.)

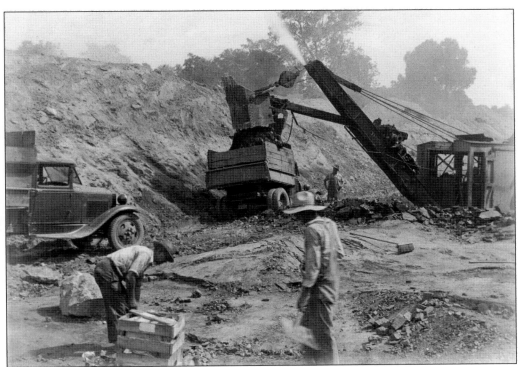

Although most coal mines in Madison County involved work in underground tunnels, this mine near Moro was an open air or strip mine. Dirt was removed from the vein of coal, which was located a few feet below the surface. Promoted by the Steirs Brothers Construction Company of St. Louis in 1934–1935, the venture was unsuccessful.

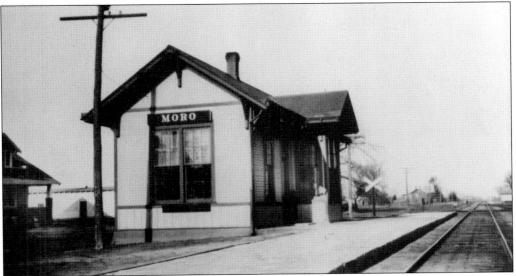

The history of Moro began with the railroad coming through town in 1853. As with many communities, the railroad brought hope of prosperity and growth. The town was first called Hampton, but the name was later changed to Moro. When the railroad line was completed through Moro Township in 1854, it had depots in Moro and Dorsey. This photograph shows the Moro Depot in 1925.

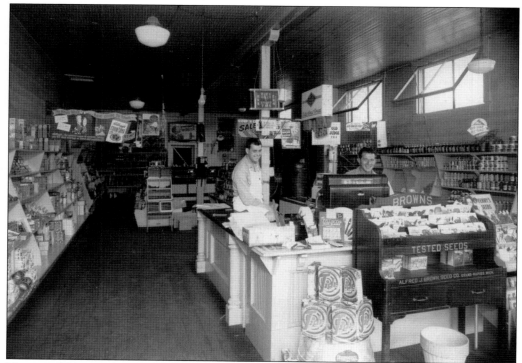

Hiram Stahl began this general store in Moro. His son, C.E. Stahl, later took over the management of the store. It was then passed to Hiram's grandson Ralph Stahl. The last owner of the store was Paul Lowenstein. This image shows the interior of the store with clerks Lindell Cooper and Kenneth Dorsey.

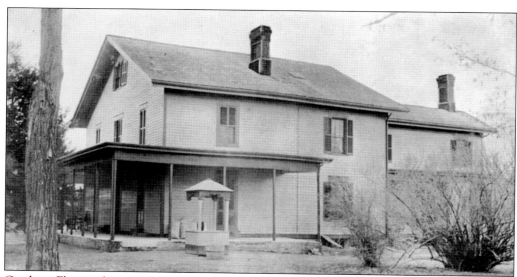

Gershom Flagg, a drummer boy in the War of 1812, came to Madison County in 1818 and settled in Fort Russell Township. He married Jane Paddock, the daughter of Gaius Paddock, and had one child, Willard Cutting Flagg. In 1865, Willard Cutting Flagg completed this home. The house stood until 1999, when it was destroyed by fire.

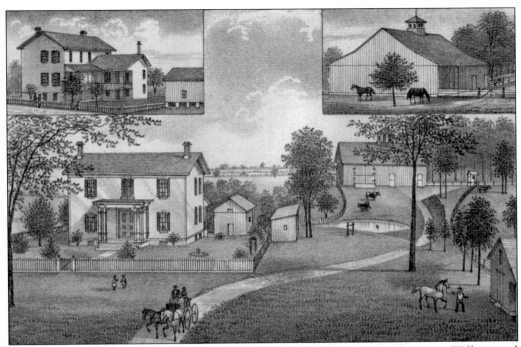

Thomas Harris and family came to Foster Township from Ohio in 1852. Two sons, William and Thomas Nathan Harris, served in the Civil War and both settled on farms in Foster Township. According to the *1894 Portrait and Biographical Record*, William was a "straightforward Republican" while Thomas Nathan was a "pronounced Democrat." T.N. Harris started this house before the Civil War and finished it when he returned.

Henry DeWerff operated a brickyard near the town of Moro. The 1882 *History of Madison County, Illinois* states that he produces a "very fine quality of brick" and "has a well arranged yard with kiln, and burns about 140,000 brick per year." This undated image shows the DeWerff family in front of their home.

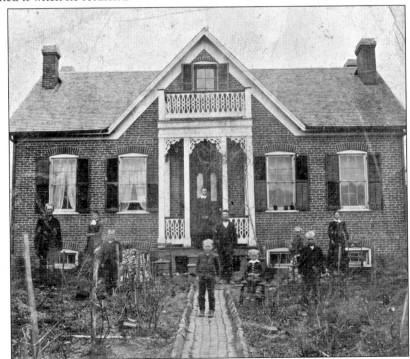

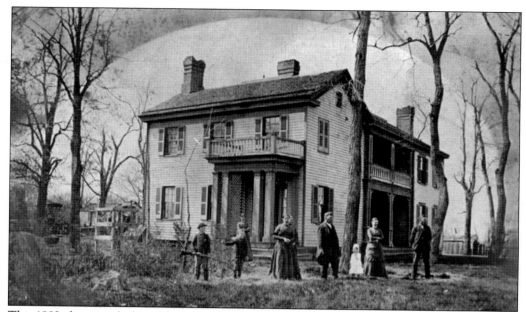

This 1882 photograph shows the Samuel L. Dorsey family at their home near Moro. According to his obituary in 1893, Samuel Dorsey "made his way from poverty to comparative affluence, and died holding the esteem of all who knew him." The community of Dorsey is named after him.

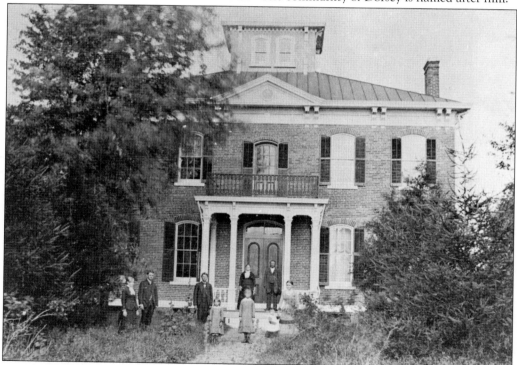

Christian Philip Smith came to the United States from Germany with his parents, Philip and Mary. After their death, he purchased his sisters' interest in the family farm. He married Frances Kaiser in 1860, and they had nine children, six of whom lived to adulthood. By 1868, he owned 1,300 acres of farmland and built this house for a cost of $10,000.

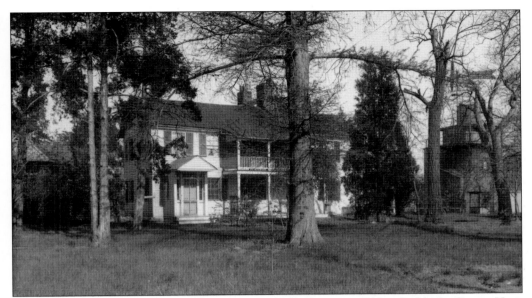

Gaius Paddock, a Revolutionary War soldier, built this home in 1819 at Paddocks Grove. He is buried in nearby Paddock Cemetery. The unique windmill and washhouse at right were added about 1880. As part of a Works Progress Administration project focusing on interesting old buildings, they were sketched and measured, and the information was placed in the Library of Congress. All have since been razed.

The grandson and namesake of the Revolutionary War soldier mentioned above, Gaius Paddock, is shown here on his centennial in May 1936. While living in Springfield, Illinois, in his youth, he became acquainted with Abraham Lincoln when he was working as a clerk in a Springfield store. He lived in St. Louis for several years until he retired to the old home place at Paddocks Grove.

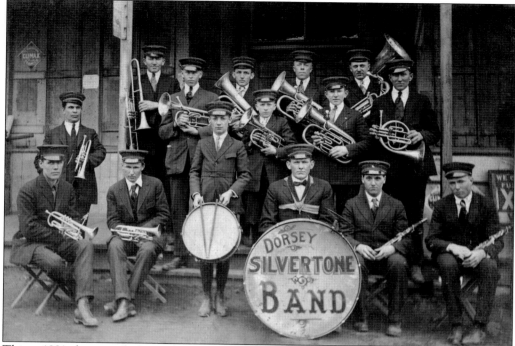

This c. 1921 photograph shows the Dorsey Silvertone Band. Nearly every community had a local band that entertained at many events. The band members are, in no particular order, William Bertels, Richard Bertels, William Lyford, Carl Johnson, Paul Johnson, Benard Bertels, Roy Bertels, Percy Heuer, Tony Kuchack, Louis Bertels, Gerhard Johnson, Wilfred Dietzel, John Enson, Alfred Johnson, and Edwin Johnson.

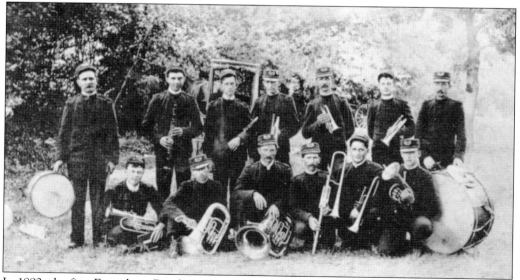

In 1892, the first Fosterburg Band was formed. It played at events in Fosterburg and neighboring communities until 1922, when it disbanded. The band was reorganized in 1954. The members of the 1905 Fosterburg Band include Charlie Harrison, Gus Brueggemann, Sam Harris, Emil Voumard, John Paul, John Harris, John Muessel, Fred Stutz Robert Whyres, John Neuhaus, John Culp, and Arthur Neuhaus.

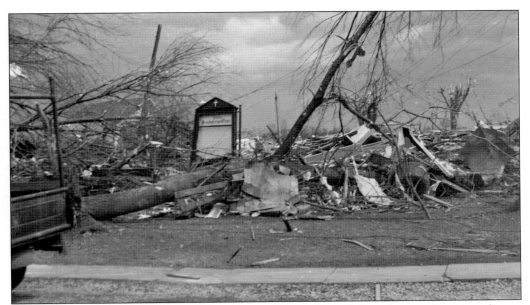

On March 19, 1948, shortly after 6:00 a.m., a tornado tore through Fosterburg and continued on to Bunker Hill and Gillespie. Many people were in bed when the tornado hit. When the storm had passed, 30 people were dead and 200 injured. The towns of Fosterburg and Bunker Hill were left in ruins. The scene above shows that only the bulletin board remained of the Zion Presbyterian Church in Fosterburg. The church, which stood to the left, and the parsonage, which stood to the right, were reduced to rubble. Shown below is the home of Glen Voumare in Fosterburg, one of four left standing in the town. Men are moving furniture and others are covering the damaged roof. Within four hours of the tornado, the Red Cross had arrived to provide assistance.

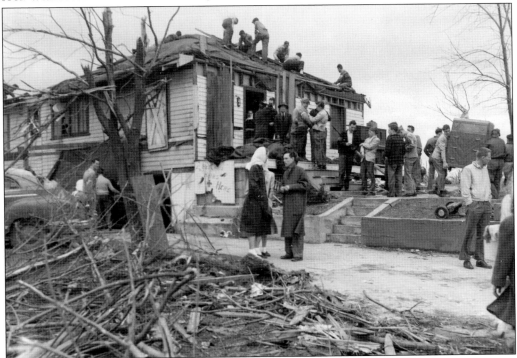

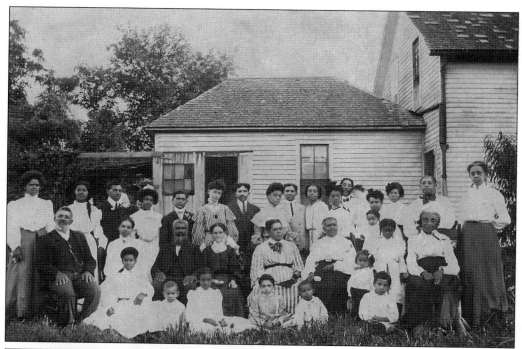

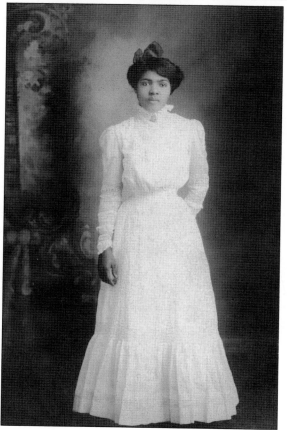

In 1904, the family of James Henry and Elinor Johnson held a reunion on the Johnson homestead, Oak Leaf Farm. The reunion lasted three days and over 100 people attended from several states. The photograph above was taken at the reunion. James and Elinor moved to Alton in 1839 and then to Wood Station in Foster Township in 1845. By 1850, they had established their homestead where they raised 11 children. James was a farmer, preacher, and founder of churches. One of their descendants, Cloto Johnson, is shown at left. She graduated from Sumner High School in St. Louis in 1912. At that time, there were few high schools available to African Americans in Illinois or Missouri. Sumner High School was the first high school for African Americans west of the Mississippi. (Both courtesy of Charlotte Johnson.)

Four

Omphghent, Olive, New Douglas, Leef, Alhambra, and Hamel Townships

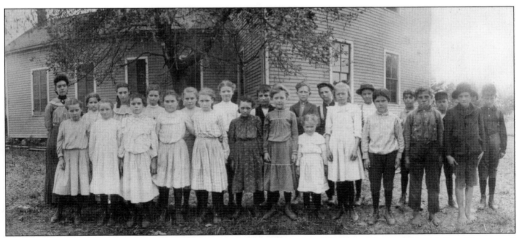

The Worden School teacher and students pictured here in 1905 are, from left to right, (first row) Clara Unger, Fanny Lamb, Lillie Long, Jennie Birmingham, Emma Kell, Valley Kell, Clara Weeks, Melinda Weeks, Hilda Wolf, Marvin Baumgartner, Levi Barstow, and Bernard Drui; (second row) unidentified, Bertha Hausemann, Abbie Barr, Mabel Massey, Bessie Piper, Maude Barstow, Richard Sandbach, James Watson, George Albrecht, John Fenton, Eddie Frankfort, Charlie Schneider, and Henry Albrecht. (Courtesy of Lewis Knackstedt.)

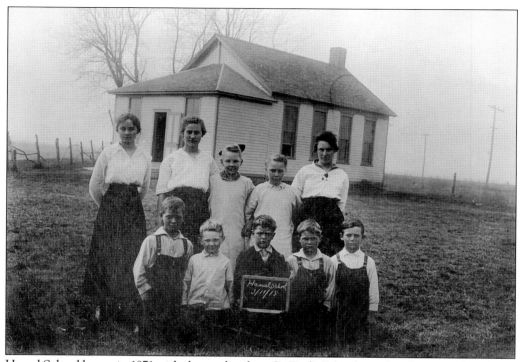

Hamel School began in 1871 with the teacher from St. Paul's School traveling between the schools to teach at both. The students and teacher at the Hamel School in March 1918 are, from left to right, (first row) Henry Stahlhut, unidentified, Edward Richter, Elmer Gueldner, and Herman Reising; (second row) unidentified, Nora Ohm, Emma Gueldner, Esther Schneider, and Elsie Wolf. (Courtesy of Betty Steinmann.)

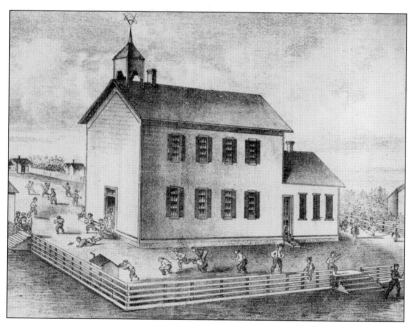

On June 14, 1867, J.A. Sanderson and J.F. Boob were hired to build a schoolhouse in New Douglas for $1,250. The building was also used as a meeting place for the Masonic lodge. This image from the 1873 *Illustrated Encyclopedia and Atlas Map of Madison County, Ill.* shows the Masonic symbol over the steeple. On February 27, 1876, the building was demolished by a tornado.

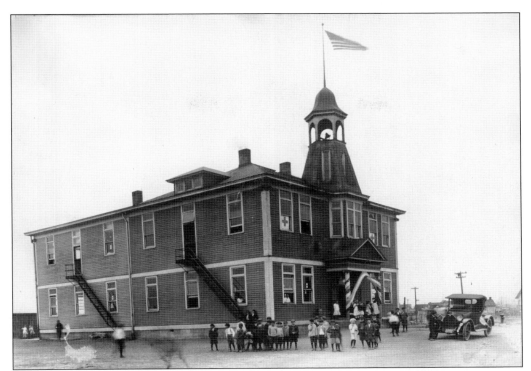

This is the Livingston School, built in 1907 and later enlarged in 1912. Problems with overcrowding in 1916 and 1917 caused the school to operate on half days. More attendance problems followed in 1918, with a smallpox outbreak that resulted in every adult and child being vaccinated, and the Spanish Influenza epidemic, which caused the school to be closed for two months. This building was used as a school until 1961. (Courtesy of Delores Brooke.)

A new high school was built in Livingston in 1926 to alleviate overcrowding. It was a two-story brick building and included classrooms on the first and second floors and a gymnasium and locker rooms in the basement. Two of the high school teachers, Edith Wilson (left) and Evelyn Waters (right), are shown in front of the new building. (Courtesy of Suzanne Dietrich.)

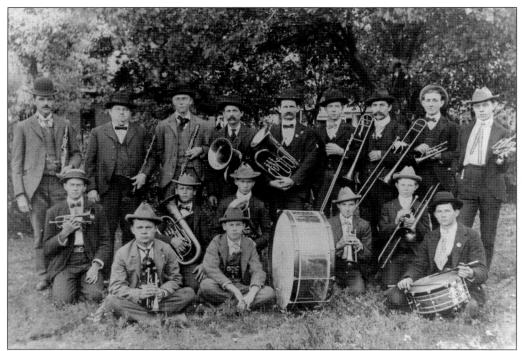

Members of the Worden band in the early 1900s are, from left to right, (first row) Fred Hagemeier, John Lannae, Adolph Schulze, Bill Hagemeier, John Schulze, and John Evans; (second row) Henry Sassenberg, John Johnson, William Schulze, Fran Lannae Sr., Frank Wolf, Gomer Evans, Joe Watson, William Schliepsick, and Henry Schulze. (Courtesy of Lewis Knackstedt.)

The Old Settlers Association was organized in New Douglas in 1894 for the purpose of preserving the memories of old times. It consisted of old settlers from Madison, Bond, Macoupin, and Montgomery Counties. It was incorporated in 1900, and John Vollentine was the first president. This photograph was taken around 1894.

The first services for St. Paul Lutheran Church were held at the parsonage in 1856 with Rev. C.G.H. Schliepsick as the first pastor. The congregation soon outgrew the parsonage, and a new church was dedicated in 1861. The current St. Paul Lutheran Church was dedicated in 1931. This photograph shows the 1861 church (left) and the 1931 church (right). (Courtesy of Betty Steinmann.)

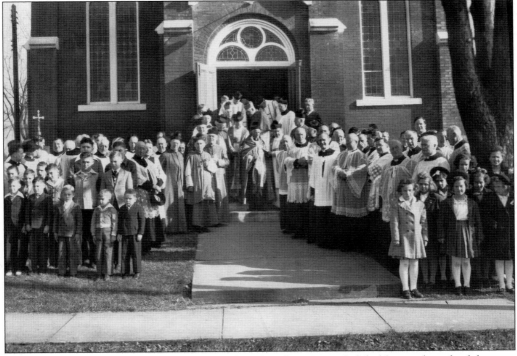

On December 3, 1947, St. Gertrude's Catholic Church in Grantfork held a combined celebration of the diamond (75th) anniversary of the church, along with the golden (50th) anniversary of the ordination of Rev. J.B. Wardein, the pastor at the time. In addition to parishioners, over 80 members of the clergy attended the celebration.

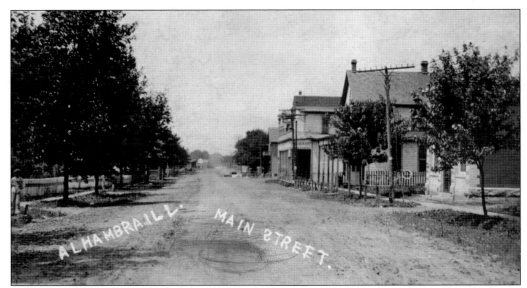

Here is an early view of Alhambra. The town name was selected by Mrs. Louis F. Sheppard, whose husband platted the village in 1849. When the Sheppards first came to the area, they stayed with the Levi Harnsberger family. Sarah Sheppard and Mary Harnsberger were reading Washington Irving's book *The Alhambra*, which prompted the suggestion for the new town's name.

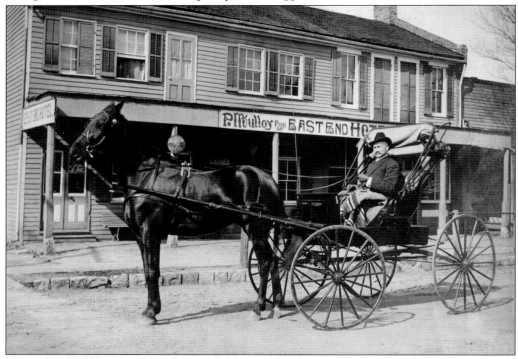

This 1907 photograph shows Peter Mulloy in front of the East End Hotel in Alhambra, which he had recently purchased from August Talleur. It was built in 1858 by George Shumann and had operated for several years under various owners. Peter's daughter Annie and son-in-law John Willman operated the hotel. They purchased it in 1910 when Mulloy's health failed. (Courtesy of Ken Gehrig.)

In 1862, Stephen Bardill opened a stone quarry and lime kiln west of Grantfork. He later sunk a shaft for a coal mine on the property but had to abandon the endeavor because of flooding. In 1886, the water was given a chemical test that revealed the mineral content. The Diamond Mineral Springs Hotel (above) was erected and the mineral springs developed into a health and summer resort. The property was later sold to Anton Kraft, who further developed it by enlarging the lake, converting the grounds to a park with fountains and flower-bordered walks (below), updating the system of waterworks for the hotel, and adding an amusement hall for dancing and billiards. The dining hall, today known as Diamond Mineral Springs Restaurant, was added later for diners not staying at the hotel. (Both courtesy of Tammy Ritzheimer-Mount.)

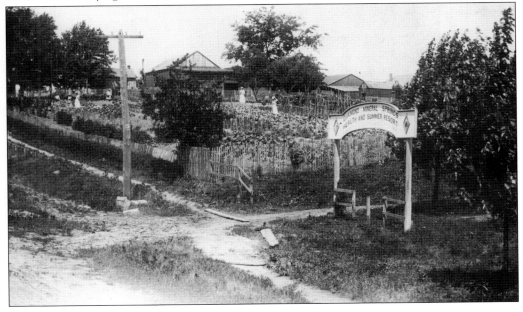

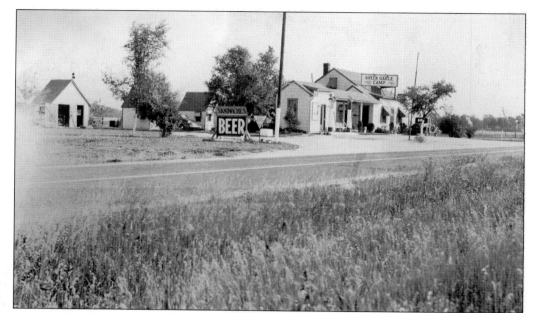

In 1931, Harry Baumgartner opened Green Gables Tourist Camp on Route 66 between Hamel and Edwardsville. Baumgartner died in 1939, and the gas station and tourist camp were sold to new owners. When Interstate 55 replaced Route 66, the tourist camp was bypassed, and it eventually closed and became a private residence. (Courtesy of Cheryl Jett.)

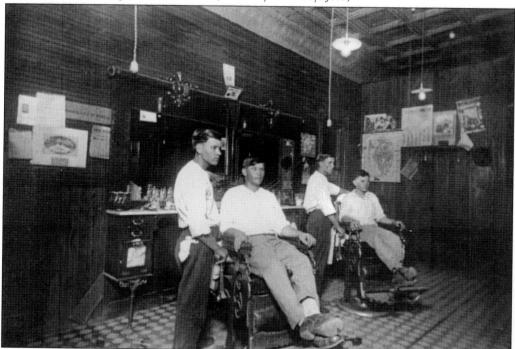

Fritz Windisch's Barber Shop in Livingston operated for many years in a building located on the west side of Livingston Avenue. The building was shared with Lefty Massinelli's Shoe Repair, which occupied the north side of the lower level while the barbershop was on the south side. Fritz Windisch is standing near the first chair, and Robert Windisch is at the back chair.

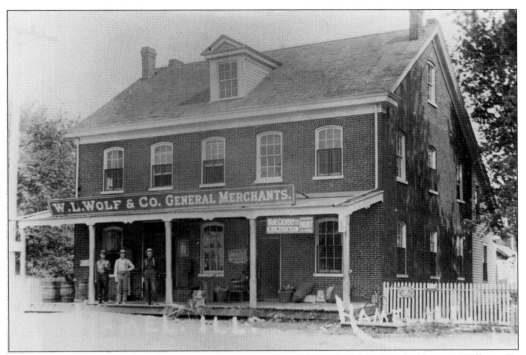

Frederick Wolf built a two-story general store in Hamel in 1865. Frederick, Ernest, William F., and finally, William L. Wolf operated Wolf's Store until 1953. It included all basic supplies needed by residents and travelers. In his advertisements, William L. Wolf used the slogan: "Place your money where your nickels and dimes count." (Courtesy of Betty Steinmann.)

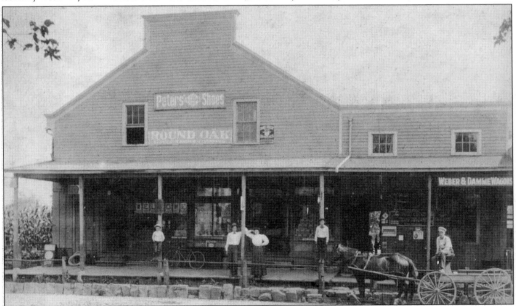

In 1866, John Gehrig and Ed Jegeman built a general store in Alhambra and called it the Gehrig & Jegeman Store. Various Gehrig family members and partners continued to operate the store for many years. This building was constructed in 1903 by Jacob Gehrig Jr., a nephew of John Gehrig, after the previous store burned in 1902. Gehrig's store closed in 2006. (Courtesy of Ken Gehrig.)

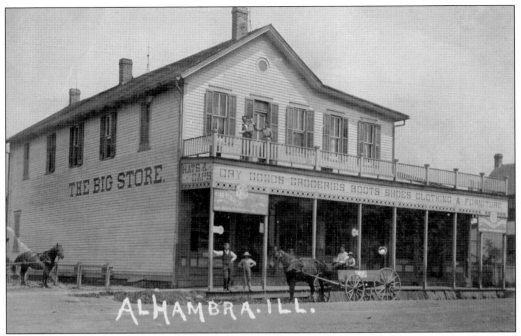

Charles Ruedy operated a store in Greencastle for several years. In 1882, he opened the Big Store on the corner of Main and East Streets in Alhambra. A store was still in operation in this building in 1949, but it was owned by Carl J. Smith and known as the Smith Mercantile. Greencastle and Alhambra were incorporated as Alhambra in 1884. (Courtesy of Ken Gehrig.)

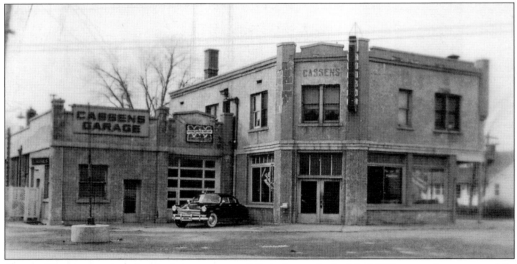

George Cassens, intrigued with the new automobile industry, built this 6,500-square-foot automobile showroom and garage in 1921 in Hamel for his Hudson dealership. In 1933, he entered into the transport business when he purchased a four-car transport trailer. The first load of automobiles consisted of two Plymouths, a Dodge, and one Hudson Terraplane.

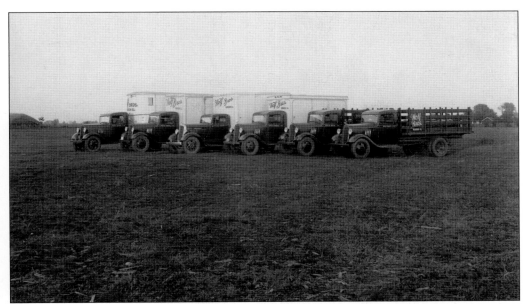

Arthur, Wilfred "Pete," and Arnold Wolf, sons of Henry and Julia Wolf, opened a milk-hauling business in the 1930s near Worden. The business, Wolf Brothers, picked up cans of milk from local farmers and took them to the dairies in St. Louis. Here, several Wolf Brothers trucks were lined up for a photograph. (Courtesy of Lewis Knackstedt.)

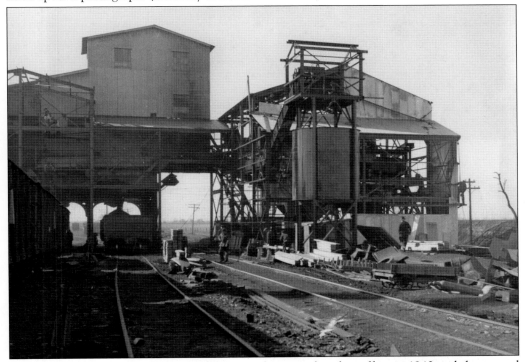

In order to comply with a St. Louis ordinance that was placed in effect in 1940 and threatened the coal industry in Madison County, coal washers (seen on the right in this photograph) were installed at the Mt. Olive and Staunton Coal Company mine in Williamson. The equipment and structures cost $100,000.

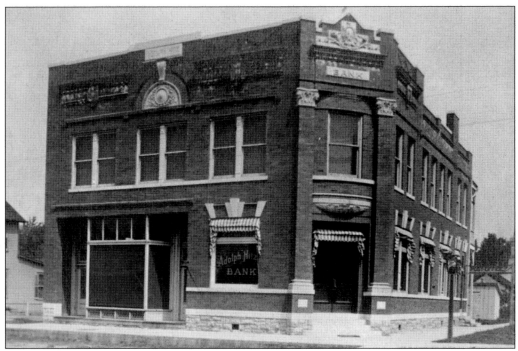

Adolph Hitz established the Hitz State Bank (above) in Alhambra in 1907. It operated for 40 years and closed when Hitz retired. He died two years later. The Hitz family home (below) was given by Louis Hitz to the Southern Illinois Synod of the United Church of Christ. It was remodeled and opened in 1952 as the Hitz Memorial Home to provide nursing care for men and women. The dedication service succinctly stated the intent of the family: "Here amidst love and understanding, we hope to bring peace and happiness and a sense of security to those who will make this their home." Adolph Hitz's wife, Louise, was one of the first residents.

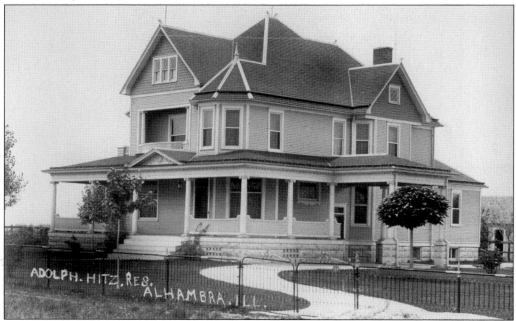

Five

WOOD RIVER AND CHOUTEAU TOWNSHIPS

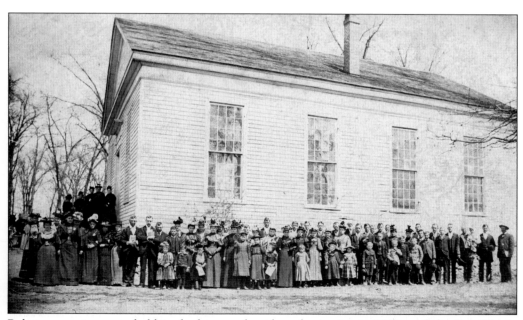

Religious services were held in the homes of residents beginning in 1802 until the first Wanda Methodist Church was built in 1809. John Gillham donated land, and Sam Gillham built the early log church. It was known as Salem until the 1870s. The structure shown in this undated photograph was built in 1890 and replaced by a brick structure in 1957.

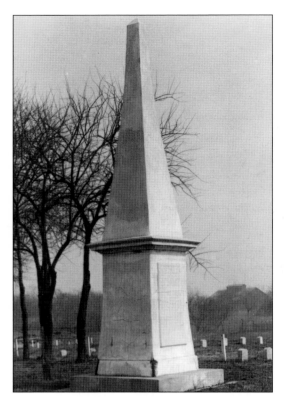

Probably one of the most infamous incidents from pioneer times was the Wood River Massacre. On July 10, 1814, Rachel Reagan, the wife of Reason Reagan, her two children, two children of William Moore, and two children of Abel Moore were killed by Indians on a Sunday afternoon while walking the mile through the woods between the Abel Moore and Reagan homes. Their bodies were discovered late in the evening by Polly Moore. The Indians were pursued by rangers from Fort Russell. The monument on the left, with the inscription shown below, was dedicated in September 1910 on Fosterburg Road by descendants of the families of the victims.

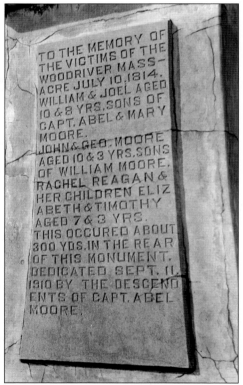

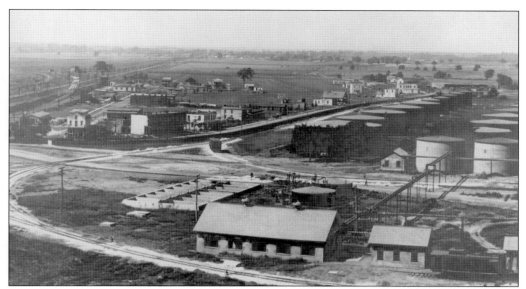

The 1908 photograph above shows the progress of construction on the Standard Oil of Indiana refinery in Wood River. The City of Wood River was incorporated in July 1908 and can be seen in the background. Standard Oil of Indiana made mail order history by ordering 192 Honor-Bilt homes at a cost of $1 million from Sears, Roebuck, and Company. The houses were for workers in various locations in Illinois, with Wood River receiving 24 houses. By 1954 the refinery had grown considerably, as shown below. Standard Oil of Indiana changed its name to AMOCO (American Oil Company) in 1985 and continued to operate the refinery until it closed in 1995.

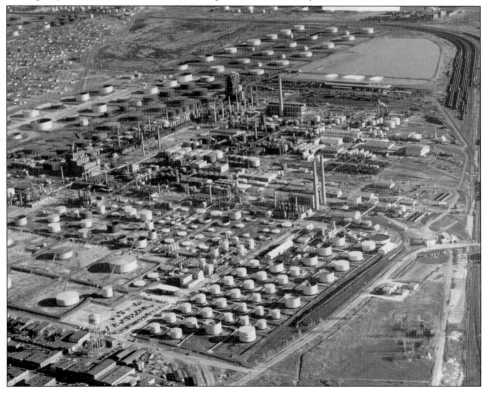

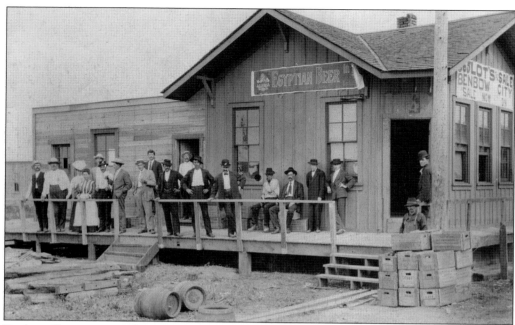

Benbow City came into being with the construction of the Standard Oil Refinery in the spring of 1907. It was a rough town of workers who came to build the refinery and included within its borders 19 taverns and an actual population of only 75. The city of Wood River grew to surround Benbow City on three sides. Benbow City was officially annexed into Wood River in May 1917. The photograph above shows the office from which lots in Benbow City were sold. The founder of the community, A.E. Benbow, is second from the left. A tavern was operated in connection with the land office. A school was also built, and the first teacher was Emily Ireland in the 1908–1909 school year. Below are some of the students at a reunion at the school in the 1950s.

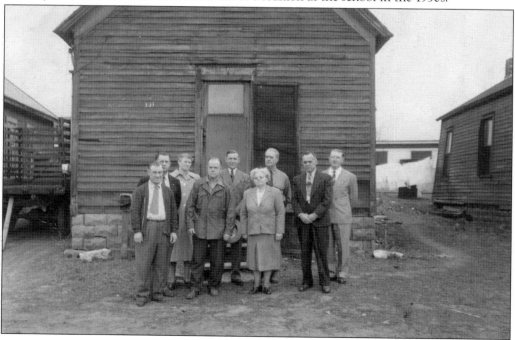

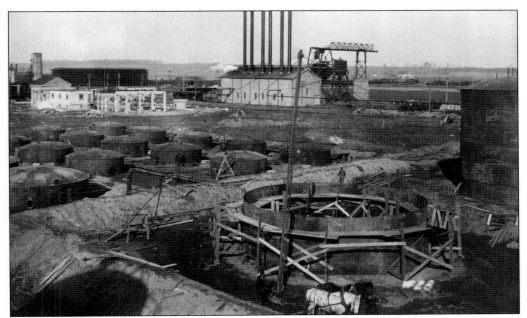

These two images show construction of the Shell Oil Company refinery in Roxana (above) and the refinery in 1938 (below). The Shell Oil Company was originally called Roxana Petroleum Company when it began in Oklahoma in 1912. Roxana Petroleum outgrew its headquarters in Tulsa, moved to St. Louis, and began building a refinery in 1917 in what would become Roxana, Illinois. During construction, six homes were built on the refinery grounds for supervisory staff, and 50 cottages were built north of the refinery for employees. This was the beginning of the village of Roxana. The refinery began operation on September 23, 1918, and became one of the nation's premier facilities. In 2000, Shell sold the refinery. It is currently operating as the Wood River Refinery.

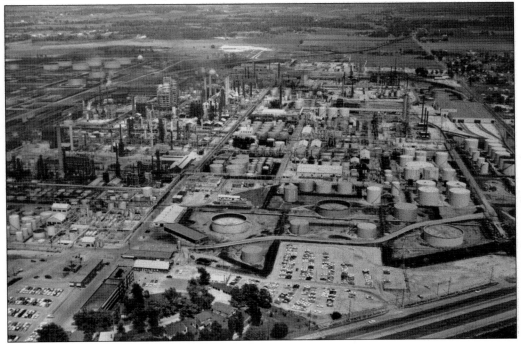

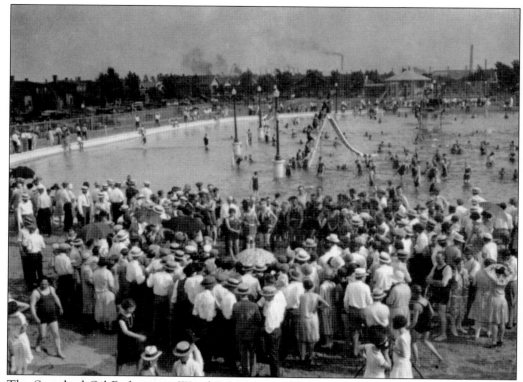

The Standard Oil Refinery at Wood River was one of the industrial mainstays of the local economy. The swimming pool in Wood River, shown here, was a gift from Standard Oil. The pool was once the largest in the United States. It opened on July 4, 1926, and attracted 15,000 visitors that day. (Courtesy of the Wood River Museum.)

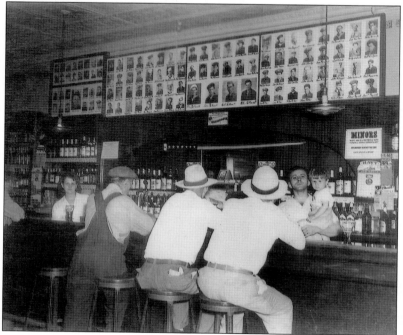

In 1940, Paul Butkovich's tavern on Main Street in Wood River proudly displayed the photographs of World War II veterans from Little Italy and surrounding areas. The photographs remained in place from 1940 to 2005. Butkovich is behind the bar holding his son; his wife, Mildred, is on the left. (Courtesy of the Wood River Museum.)

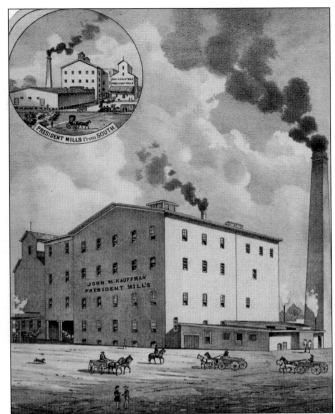

These two images of Bethalto are from the 1882 *History of Madison County*. The plat for Bethalto was recorded in July 1854. The community is located in both Wood River and Fort Russell Townships, with Prairie Street the dividing line between them. President Mills and Elevator (right) began in 1859. This image shows the second building, built in 1877 after the first mill was torn down. This building was destroyed by a dust explosion and fire in August 1882. A new brick mill was constructed, but it was also destroyed by a dust explosion and fire in March 1895. It was not rebuilt. The image below shows the business block of Neisler & Randall, "dealers in drugs, hardware, and agricultural implements."

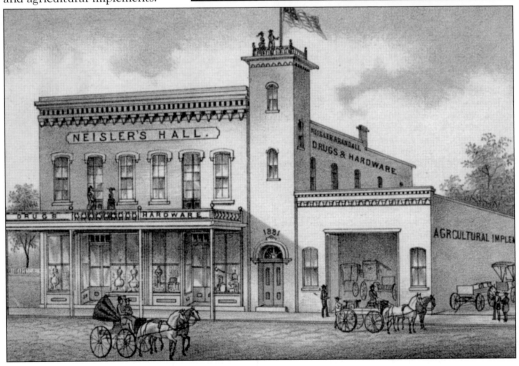

Shadrach Bond Gillham was born about 1831 and served as chairman of the Madison County Board of Supervisors in the 1880s. He was a member of the large Gillham family, early settlers of Madison County. James Gillham was the first of the family to see Illinois in 1794, when he was searching for his wife and children who had been kidnapped by Indians from his home in Kentucky. After recovering his family, he returned to Illinois in 1797 and settled in Chouteau Township. His wife, Ann, was awarded 160 acres of land in this township for the hardships endured during her five years as a captive. Other Gillham brothers and their families soon followed, and these hardy pioneers settled not only in Madison County but continued to move throughout Illinois and figured in the history of many counties.

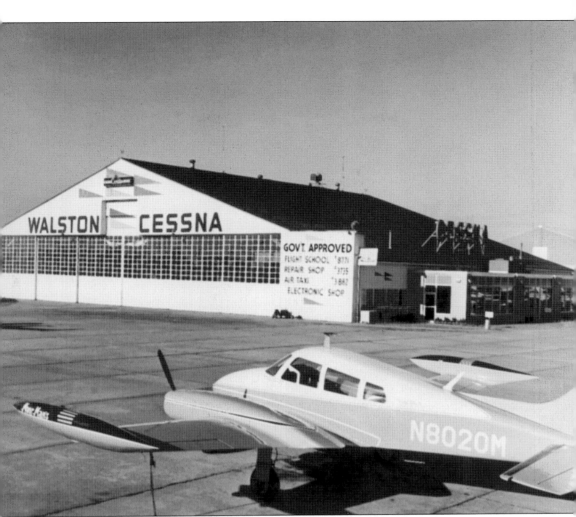

Wood River Air College was founded by Everett Wiegand in 1928 on a grassy field west of what is now the airport. In 1945, M.D. Walston and Gene Tumbleson leased 40 acres near East Alton, used an Army surplus tent for a hangar, bought a Boeing Stearman and two Porterfield airplanes, and started training student pilots, many of them servicemen returning from World War II. In 1946, Civic Memorial Airport Authority purchased the property, built a hard-surfaced runway, and took over operation. Walston opened a Cessna distributorship in 1947. Within eight years of opening, it became the largest Cessna outlet in the world. In 1984, the name of the airport was changed to St. Louis Regional Airport. Premier Air Center purchased Walston Aviation and established its headquarters at St. Louis Regional Airport the same year. (Courtesy of John Celuch.)

Formal education on Chouteau Island began about 1820 when a log school was erected on a site chosen because it was fairly high ground. After the flood of 1844 severely damaged the school, a new log structure was erected further inland. A new frame building at a more convenient location on land owned by H.F. Pattengill was built in 1860 and used for the next 52 years. The school building pictured here was the last Atkins School building, built in 1913. Floods damaged the building in 1943, 1944, and 1947. The district was consolidated into Granite City schools in 1950, and Atkins School was closed.

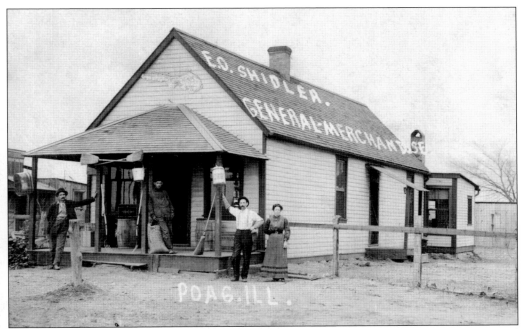

The first general store in Poag was opened by Fred Behrendt in 1904. The lumber, doors, and windows for the store and the blacksmith shop next door came from a building dismantled at the 1904 World's Fair in St. Louis and shipped by rail to Poag. The store was sold to Ed Shidler, shown in this postcard. These two businesses were later made into residences.

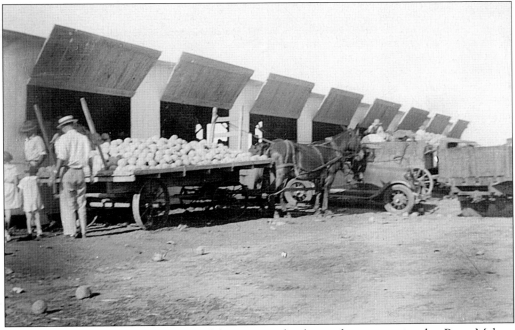

This undated photograph shows one of the many melon barns that once existed at Poag. Melons have been grown at Poag since the earliest days. According to a history of Poag written by Alvina Ringering, "When the melon industry was at its peak, refrigerated rail cars came from St. Louis, were loaded and after re-icing at Peoria, went on to Detroit and Chicago."

Route 66 traveled across the Chain of Rocks Bridge on its way to California. The bridge was built in 1929 at a cost of over $2 million. The 22-degree bend in the bridge was designed so that southbound riverboats could align with the currents, avoiding the bridge piers and the two water intake towers. In 1939, it was purchased by the city of Madison, and a 5¢ toll was charged on the Missouri side to cross the bridge. After the I-270 bridge opened in 1966, traffic declined, and the bridge was closed in 1968. In June 1999, after basic repairs were completed, it was opened to pedestrians and bicyclists, and several events are now held every year on the bridge. This stylized view is from the Missouri side of the Mississippi, with the tollbooths in evidence.

Six

EDWARDSVILLE TOWNSHIP

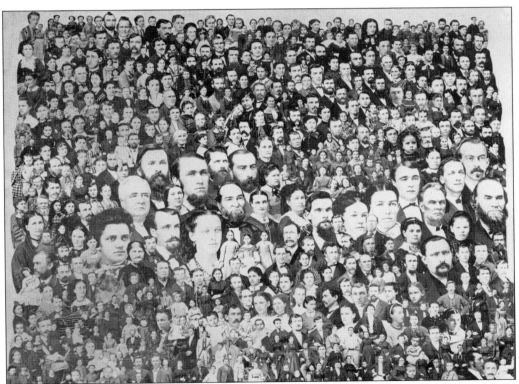

This Civil War–era composite photograph of Edwardsville residents was created by Edwardsville photographer Harry Rundle. Men, women, and children are included in this amazing image, with all of the original photographs taken and arranged by Rundle. A few of the residents in the photograph are Dr. John Weir, E.M. West, Margaret and George Bickelhaupt, Cyrus Happy, John S. Trares, L.C. Keown, and Alonzo Keller.

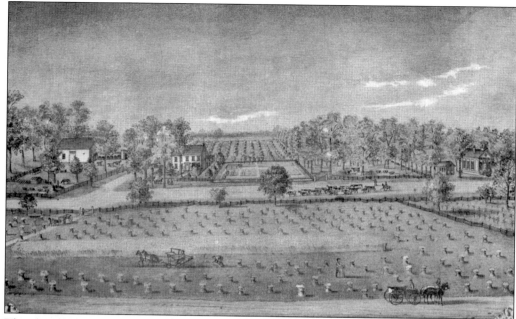

This sketch from the 1873 *Illustrated Encyclopedia and Atlas Map of Madison County, Ill.* shows the farm and residence of John Tartt, located where present-day Illinois Route 157 and Center Grove Road intersect near Edwardsville. Note on the far right of the sketch the Methodist church and schoolhouse. This was Center Grove Methodist Church, which closed about 1890.

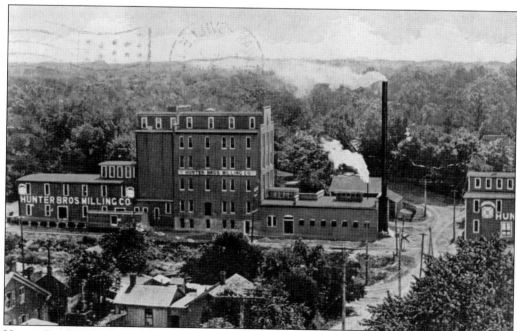

Hunter Brothers Milling Company began in 1905 and was located along the Wabash spur on West High Street at Second Street in Edwardsville. The mill produced flour under the brand names Alma, Good as Gold, and Orchid. In 1911, it became Edwardsville Milling Company and then the Blake Milling Company in 1914. The mill burned in 1926 and was not rebuilt.

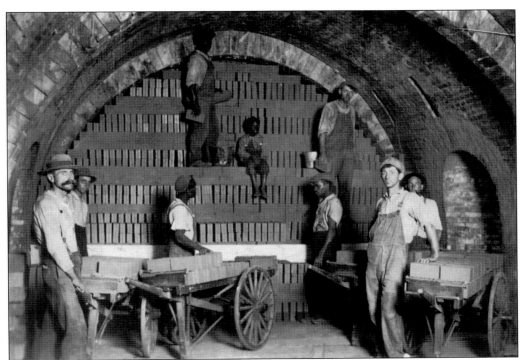

Workers at Richards Brick Company in Edwardsville are shown here stacking bricks for firing. In 1890, Benjamin Richards, a bricklayer, had trouble obtaining a steady supply of brick. He purchased half of the Springer and Tunnel Press Brickworks and eventually shifted his interest to making bricks instead of laying them. He purchased the rest of the brickyard and incorporated Richards Brick Company in 1905.

Coal mining was one of the largest industries in Madison County for many years. The Donk Brothers Thermal Mine was located near Center Grove Road and began operating in 1920. In 1927, motion pictures of the mine were shown throughout the country as an example of a model modern mine.

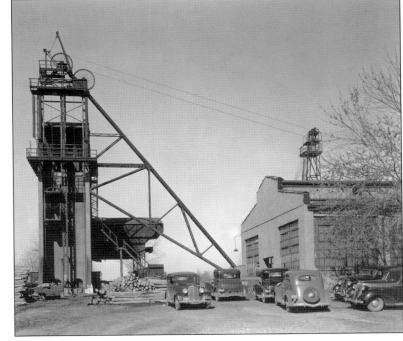

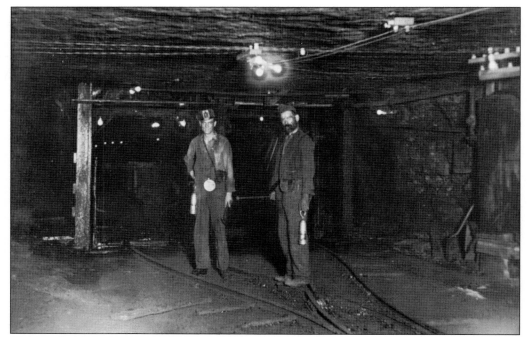

Glen Carbon began as a coal mining village. Underneath Glen Carbon are seven veins of coal. One year before Glen Carbon was incorporated, the Madison Coal Corporation was formed to "mine and sell coal and other minerals." It owned and platted much of the village, and its no. 1, no. 2, and no. 4 mines were located in Glen Carbon. The image above shows two employees of the mines, mine boss Charles Thaxton at left, and Mr. Coleson at right. After the coal was mined, it was shipped by rail to local markets. Shown below are miners posing in front of a loaded car on the Illinois Central tracks near Madison Coal Mine no. 2.

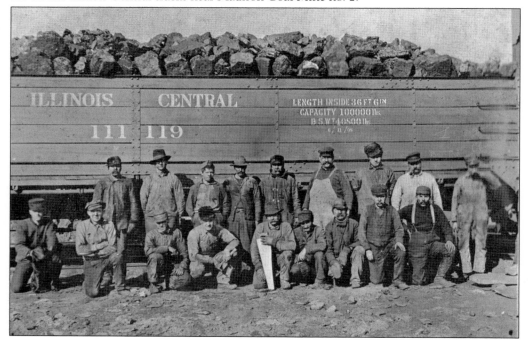

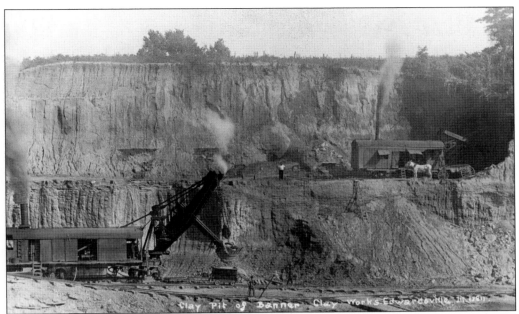

Above, a steam shovel works to remove clay used in the making of bricks by the Banner Clay Company of Edwardsville. The company produced paving bricks, which were much harder than bricks used for buildings. The image below shows the large complex of Banner Clay. The clay pit shown above is in the foreground and has begun to fill with water. It is known locally as the "shale pit," and for many years was a dangerous swimming area for local youth. In the background is the tipple for the Home Trade Coal Mine. A railroad spur provided transportation for the products of both Banner Clay and the mine.

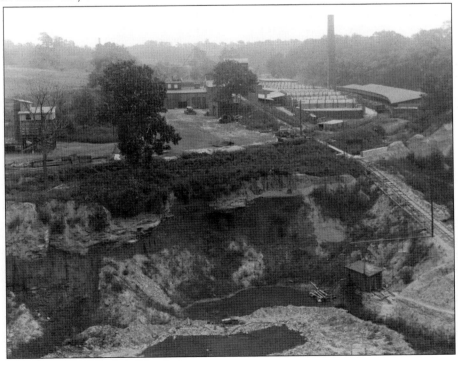

In the 1890s, N.O. Nelson moved his factories and his workers from St. Louis to land near Edwardsville to begin his model village, Leclaire. Nelson was a progressive thinker and hoped to provide his workers and their families with good homes at a low price, along with schools, parks, and playgrounds. This area, now a part of Edwardsville, is the Leclaire Historic District. The buildings of the N.O. Nelson Manufacturing Company shown below were built to provide good natural light and ventilation to create a better working environment. Today, many of the factory buildings have been remodeled, and the facility is the Edwardsville Campus of Lewis & Clark Community College.

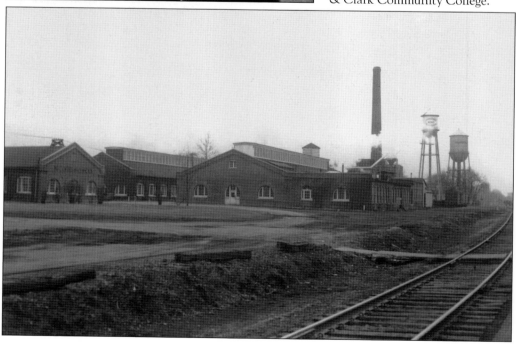

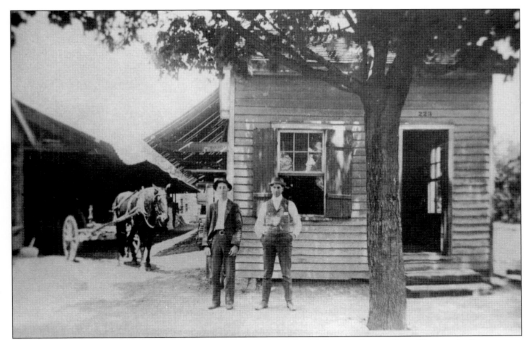

This c. 1900 image of the Illinois Lumber Company in Edwardsville shows the office with the storage sheds for lumber behind. The firm began in Bethalto in 1867 and moved to Edwardsville in 1874. John Stolze was the company's founder; it was named the Stolze Lumber Company until 1932.

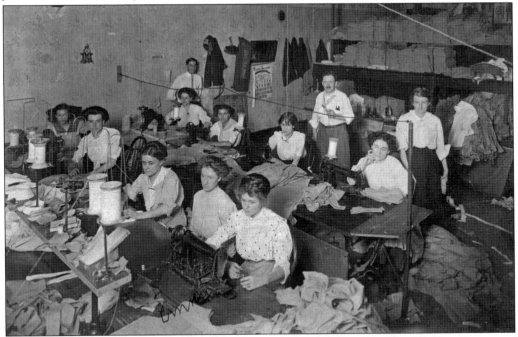

According to an article in the *Edwardsville Intelligencer*, the Jack Diamond Shirt Factory of Edwardsville "gave employment to a number of people, principally girls, who receive good wages the year 'round, and work under the most pleasant, sanitary conditions." The factory mostly made men's work shirts, which sold for 50¢ each.

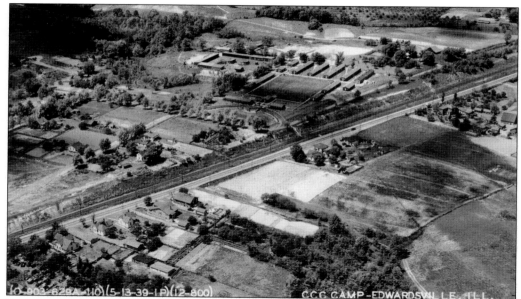

In August 1935, the Civilian Conservation Corps (CCC) camp, Camp Wheeler, was established at Edwardsville. The CCC was a public works program established during the Depression for unemployed, unmarried men ages 17 to 28, who were paid $30 a month, $25 of which was sent home to their families. Through this program, many updates were made nationwide to parks and roads. The camp was located near where Vadalabene Park is today.

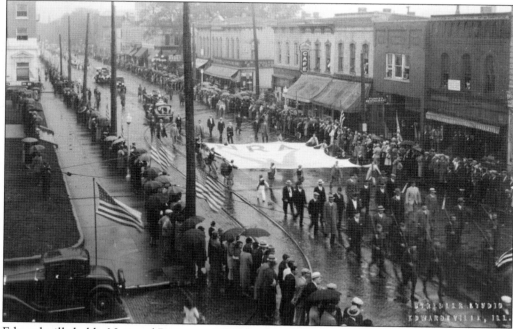

Edwardsville held a National Recovery Administration (NRA) parade on October 20, 1933. The NRA was another Depression-era program designed to stabilize industrial production and prices. The symbol of the program was a blue thunderbird. In this parade, 21 *Edwardsville Intelligencer* newspaper carriers carried the NRA flag. The parade was a demonstration of Edwardsville's cooperation with the program.

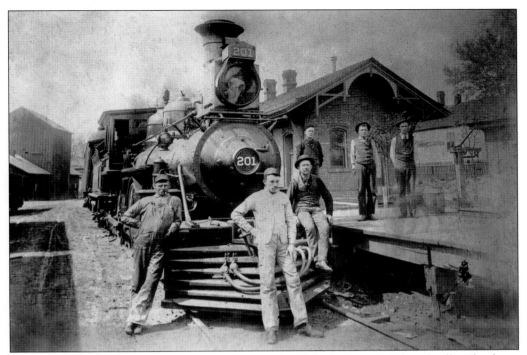

Railroad workers pause from their duties to pose at the Wabash Depot in Edwardsville. The depot was located on St. Louis Street, just east of Vandalia Street. The men in this 1895 photograph are, from left to right, engineer Dalton, fireman Clawson, brakeman Thomas Dailey, station clerks William Berleman and George Hanser, and telegrapher W.R. Kearney.

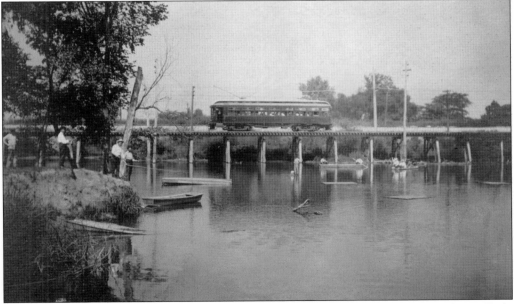

The Yellow Hammer, part of the Illinois Traction System, is shown here at Center Grove Park. The park was a popular location for picnicking. Special trains from surrounding towns carried residents to and from the park each Sunday during the spring and summer. Both the park and the Yellow Hammer have long since disappeared.

The Stephenson House was built by Benjamin Stephenson in 1820. Stephenson helped to bring the Federal Land Office to Edwardsville and was appointed to head that office by Pres. James Madison. He died in 1822 and the house was owned by many individuals until the city of Edwardsville purchased it in 1999. It was renovated, and today it is a local landmark and historic learning center.

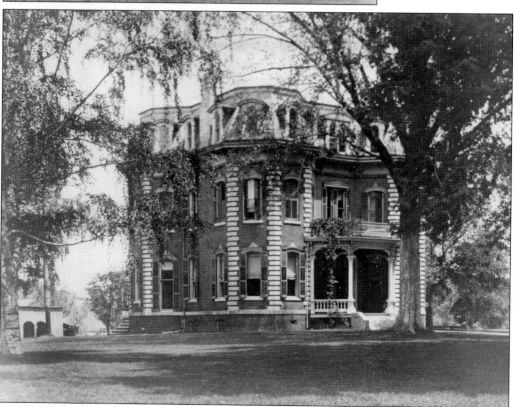

The William Erastus Wheeler home, built in 1867, was located at 419 East Vandalia Street in Edwardsville. It was used as a residence for several years by the Wheeler family and then as a school. It was razed in 1928, and a new home was built on the property. A similar home was built by John S. Trares, which is currently the Weber & Rodney Funeral Home.

Phoebe Montgomery (right) was the daughter of Nelson Montgomery and moved to a house (below) on St. Louis Street with her mother after her father died. She was a horsewoman and the new house was close to the race track at the fairgrounds on St. Louis Street, where she could race her horse, Joe Joker.

The ground-breaking ceremony for the new US Post Office in Edwardsville took place in December 1913 (above). The first spade of dirt was turned by W.M. Crossman Jr., the grandson of postmaster T.M. Crossman. Pictured are, from left to right, excavation contractor William Probst, construction superintendent Eugene Sheets, assistant postmaster W.M. Crossman Sr., building contractor V.E. Taylor, and postmaster T.M. Crossman. The post office was completed on March 16, 1915. The building (below) still stands on Hillsboro Street in Edwardsville, but it is no longer the post office. The current post office in the 100 block of North Kansas Street was dedicated in July 1966.

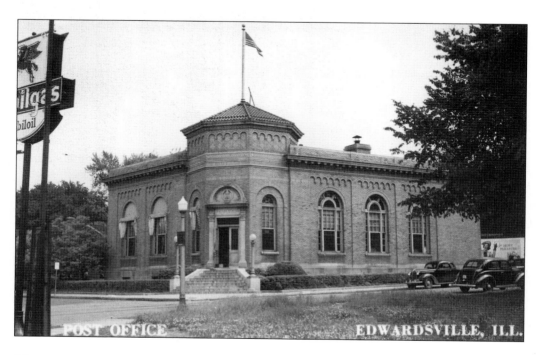

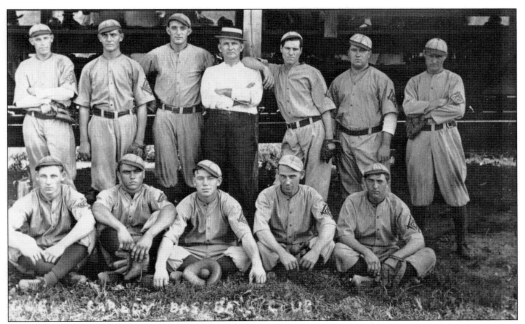

Baseball was a popular sport in Madison County in communities of all sizes. By 1897, Glen Carbon had three baseball teams. This image shows the Glen Carbon baseball team about 1912, with, from left to right, (first row, seated) unidentified, Joe Vino, Pete Wechman, unidentified, and Bill Moore; (second row, standing) Arch Evans, Herman Hennings, Bill Libby, manager Chid Henry, Bert Evans, John Schilla, and unidentified.

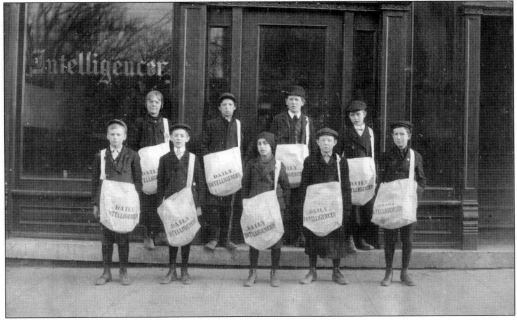

In January 1907, the first newspaper carriers for the *Edwardsville Intelligencer* pose in front of their office. The carriers are, from left to right, Warren Sommerlad, Louis Miller, Chester Spaulding, Paul Greenbusch, Edwin Baker, Clarence Dunn, Joseph Agles, Leo McNeilly, and Harry Sesser. The *Edwardsville Intelligencer* began publication in 1862 and celebrated its 150th anniversary in 2012.

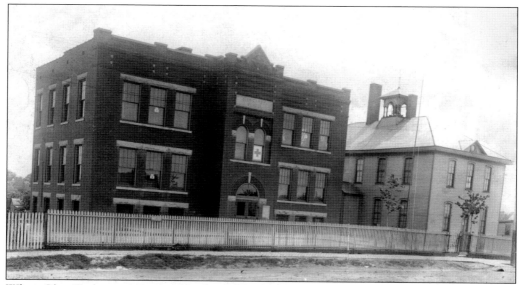

When Glen Carbon was incorporated in 1892, there was already a two-room brick school. A few years later, a four-room frame school building was added. Enrollment continued to increase, and in March 1913, a referendum passed to build a two-story brick school. The original brick school was razed, and the new school built on that location. This image shows the new brick building along with the frame schoolhouse.

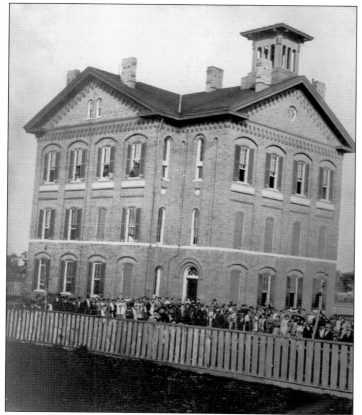

The Dale School in Edwardsville was named for Michael G. Dale. The three-story structure was built in 1864 at a cost of $13,500 and stood on North Kansas Street between College and High Streets where Columbus School is today. The school could accommodate 350 students. In 1910, the building was torn down to make way for the new high school building, which is now Columbus School.

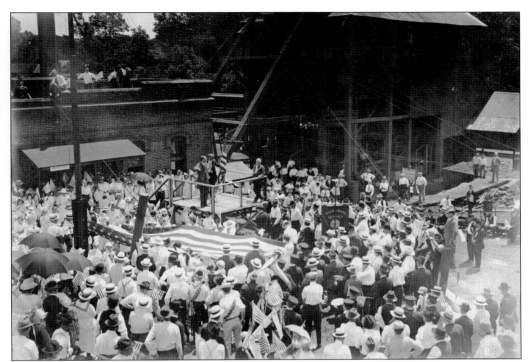

A Liberty War Bond rally was held on July 4, 1918, at Madison Coal Corporation's No. 2 mine in Glen Carbon. C.H. Burton is on the platform making a patriotic speech encouraging the purchase of Liberty Bonds. In recognition, Burton was presented with a large flag, and a flagpole was erected in his yard.

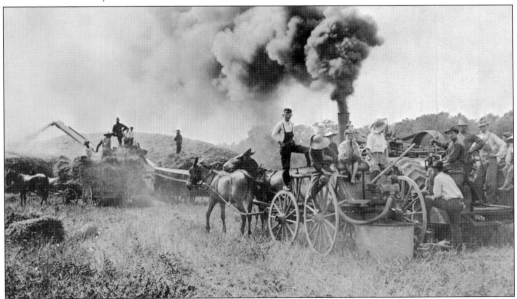

Agriculture was another mainstay of the economy in the Glen Carbon area. John Helfer's steam threshing machine is in operation here at the Shashek Farm around 1916. Even with the steam thresher, the job required many men to complete the field work, and many women to provide food for the hungry crew.

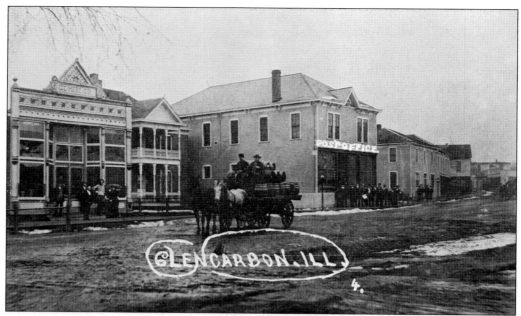

This is Main Street in Glen Carbon in the early 1900s. The buildings include, from left to right, the Company (Cooperative) Store, W.B. Rasplica home, Knights of Pythias building, Star Brewery, and the Kelly Lawson building. The Knights of Pythias building included W.B. Rasplica's store and the post office on the first floor.

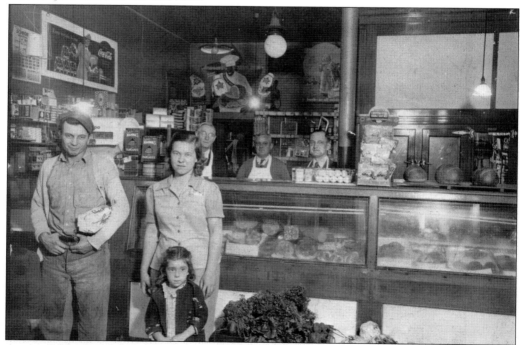

Anton, Edward, and Robert Schroeder pose behind the counter of the Schroeder Brothers Meat Market in Glen Carbon in the 1940s. The Schroeder family came from Germany in the 1870s and settled in the area in 1880. The store was originally started by Christ Schroeder, and his brother Anton joined the business in 1896.

Seven

PIN OAK, MARINE, SALINE, HELVETIA, ST. JACOB, AND JARVIS TOWNSHIPS

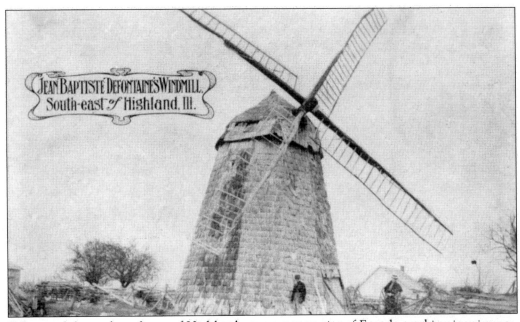

Sebastopol, located southeast of Highland, was a community of French-speaking immigrants. Probably the most famous landmark in the area was a windmill built by Jean Baptiste DeFontaine to grind grain into flour. The windmill was built entirely of wood with no nails. Even the cog gears were of wood. It was 12 sided and conical in shape. After DeFontaine's death in 1890, the mill fell into ruin.

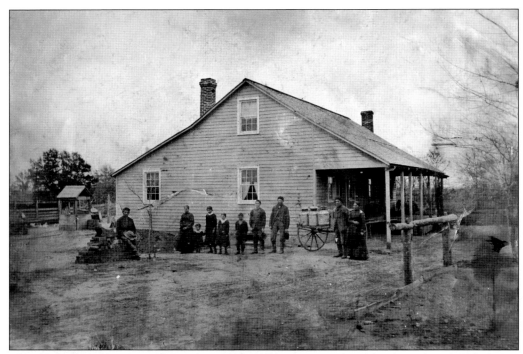

The Jacob Kleiner home was located two and a half miles east of Highland. Jacob and Wilhelmina Menz Kleiner had 10 children; eight of them are pictured here. The Kleiner family members in this c. 1882 tintype are, from left to right, Albert, Hermina, Mathilda, Louisa, Emma, Robert, Jacob Jr., Louis, and parents Jacob and Wilhelmina.

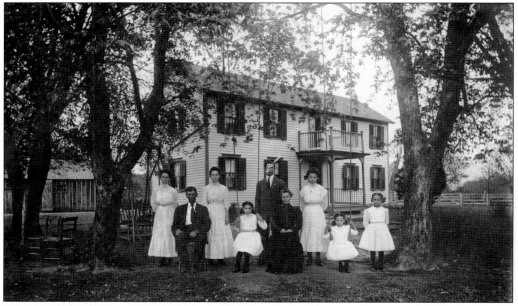

Donley and Hettie Brooks and their children are shown in front of their farm home in Marine Township about 1910. The house, originally built by Donley's father, Martin, was remodeled extensively about 1900. It originally had a long front porch, which was removed and replaced as shown here.

Emsley Keown built this large house in Marine Township before 1873. He married Caroline Edwards in 1854 but she died in 1859. He married his second wife Anna Ground Evans in 1860, and they had several children. Emsley raised thoroughbred horses and had a racetrack on his property. He accumulated over 1,000 acres by purchasing small farms in the area.

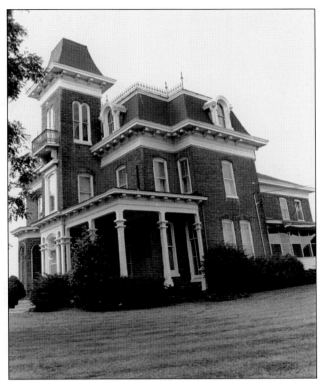

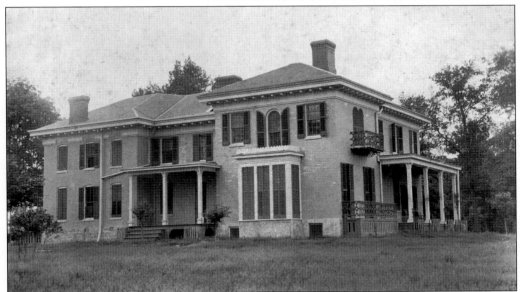

In 1836, St. Louis banker Solomon Hinckley Mudge visited the area near present-day Grantfork and decided it was the ideal location for a summer retreat. He built a frame house on 1,080 acres and named the estate Oakdale. In the late 1840s, the house burned to the ground; construction of a new one, built of brick, began immediately. Two sons, Will and Hinckley, joined the Confederate army during the Civil War. Hinckley died in Virginia, but Will returned after the war, and he and his wife lived on the estate until 1881, when they moved into Edwardsville. The estate again became a summer home. (Courtesy of Stephen Mudge.)

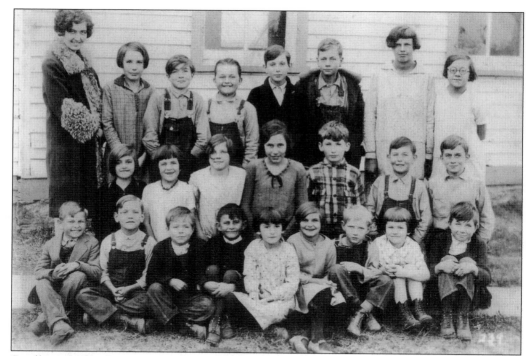

Small rural schools were common in Madison County. Tontz School was a typical rural school and was located in section no. 6 in the northern part of Saline Township, about two miles west of Grantfork. The unidentified members of the 1928 class are shown here.

St. Jacob Township was the first to consolidate schools in Madison County. The goal was to close all of the country schools where one teacher taught all eight grades in one room. Shown here are the students at Virgin School in 1917. It was the last of the country schools in the township to close.

The school building (right) was erected in Marine in 1874 at a cost of $10,000 and served grades one through eight. Two years of high school were added in 1918, which was extended to three years in 1924. The last high school class graduated in 1951, and the school continued to be used as a grade school until 1956. In addition to the grade school and high school, Marine started a nursery school for two- to five-year-olds in 1934. The photograph below shows grades one through four at Marine School on February 9, 1925. The teachers were Nellie Bilyeu (left), grades three and four, and Alberta Harris Mebold (right), grades one and two.

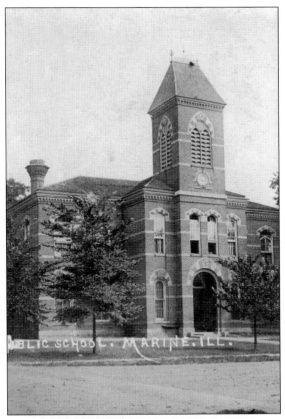

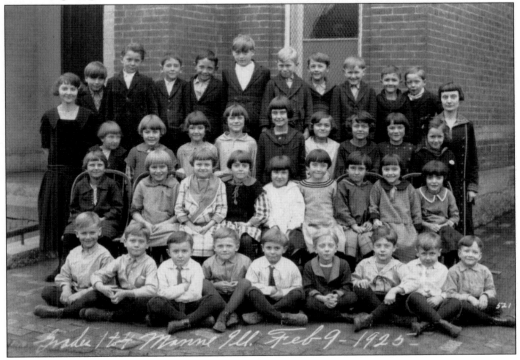

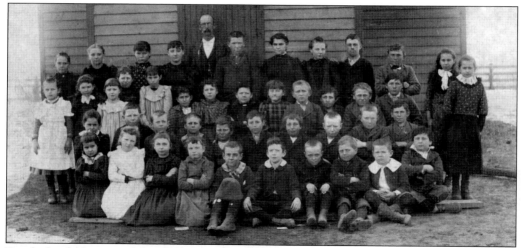

Rural schools that served the children of Pin Oak Township included Loos, Maple Grove, Mt. Zion, Pin Oak, Sylvan Hall, and Union Grove. This photograph shows W.P. Sweeney and his students at Pin Oak School in 1894 or 1895. Some of the names listed on the back of the photograph include Baird, Bartlett, Bast, Bode, Bishen, Breve, Buchta, Buckles, Friedhoff, Kuhn, Moore, Richards, Sickbert, Taylor, and Wolbrink.

Angeline McCray Dewey, widow of Dr. John S. Dewey, bequeathed 400 acres of land and $3,300 to be used to establish a high school with free tuition "to all persons under the age of 26 years residing within the limits of the common school district in which the town of Troy is included." The McCray Dewey Academy in Troy was the result.

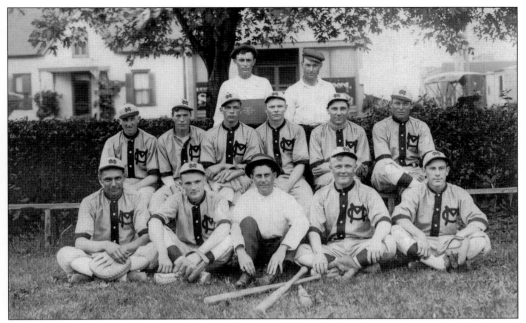

This c. 1917 photograph of the Marine Commercial baseball team was taken in front of Tip Schaeffer's home and tavern. It was sponsored by the Marine Commercial Club. Meeting minutes from the club in 1924 show that men paid 35¢ admission, and ladies and children (over 12 years) paid 15¢ admission to baseball games.

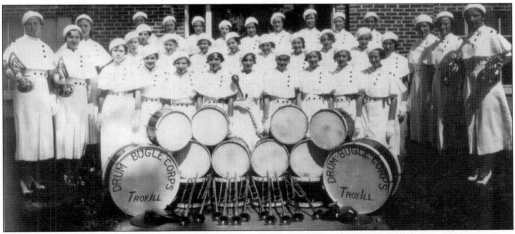

The Troy Drum and Bugle Corps began about 1930 and consisted of young women in their teens or 20s. Most of the music was taught by ear, since many of the members could not read music. The group performed in drum corps competitions, parades, and various other events in Troy and surrounding communities. Note that these young women marched in one-and-a-half-inch heels.

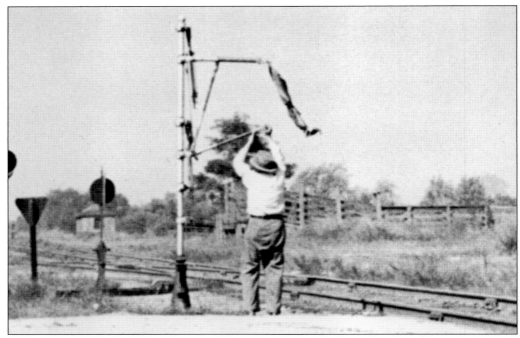

This is the old method of sending mail from Marine. In this photograph, John Nemnich, the dispatcher, hangs the mailbag on a pole near the railroad tracks. As the passenger train passed, a mail clerk on the train caught the bag with a hook and pulled it into the mail car.

Jacob Schultz built the first house in St. Jacob. In 1849, Jacob Schroth opened a store and tavern, calling it St. Jacob House. When a post office was established in 1851, the two Jacobs agreed upon the name St. Jacobs. Eventually, the name was changed to St. Jacob. Shown here is an early street scene in St. Jacob, with St. Jacob House in the background.

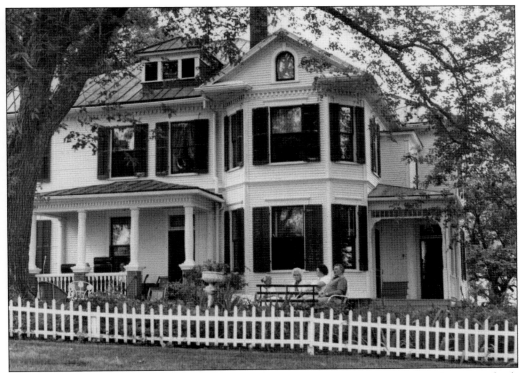

Louis Latzer, one of the forces behind the success of Helvetia Milk Condensing Company, built this home in 1901 for his wife and seven children. The house had one of the first telephones in the community and was one of the first with running water. Other luxuries included speaking tubes in many of the rooms, a gas light system, and plenty of space.

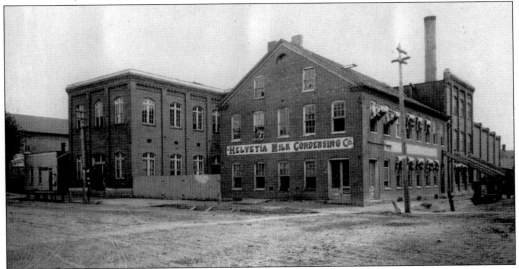

Helvetia Milk Condensing Company, which would become Pet Milk Company, was the originator of condensed milk. The company officially began in Highland on February 14, 1885, but after some trouble with the product spoiling on store shelves, production stopped in August 1887 until the process could be corrected. In December 1887, the plant reopened and production began again. Production continued at the Highland plant until 1920.

In 1906, after a request from a local Catholic priest, John, Louis, and Adolph Wick joined their talents of watchmaking and cabinetry to produce the first Wicks pipe organ. Wicks Pipe Organ Company of Highland was known for attention to detail and a personalized touch. It continued to produce organs for customers worldwide until January 2011, when it announced the cessation of production due to economic conditions. (Courtesy of Roland Harris.)

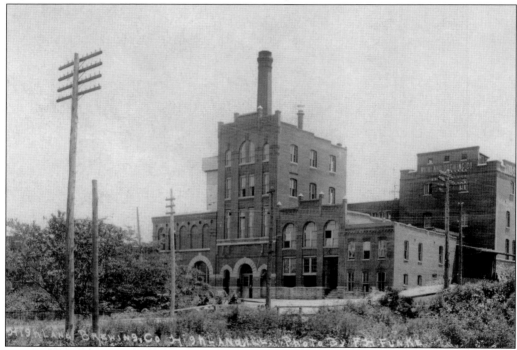

In 1857, Carl Bernays sold the Highland Brewing Company to Gerhard Schott and his son Martin. Christian Schott, another son, joined the business at this time. In 1866, Gerhard sold his share to his sons and returned to Germany. A new brewery was started in this year, with homes for the Schott families built nearby and connected to the brewery by tunnels. The brewery was sold in 1948.

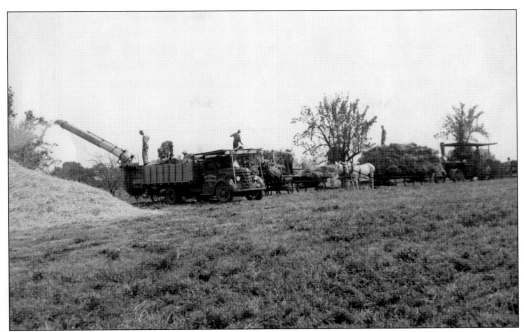

The horse and steam engine threshing rig was the common mode of wheat threshing in the early 1900s. It was a large operation, involving several workers, pieces of equipment, and horses. The last of the steam-propelled threshing outfits in Madison County (shown above) was operated by Oscar Buenscher and his team of about 16 farmers from Kuhn Station in Pin Oak Township. Each "run" would be finished in a few days. In 1939, the one-man threshing outfit below made the rounds in Madison County, providing a much quicker threshing operation. The era of steam and horse-drawn threshing was drawing to a close.

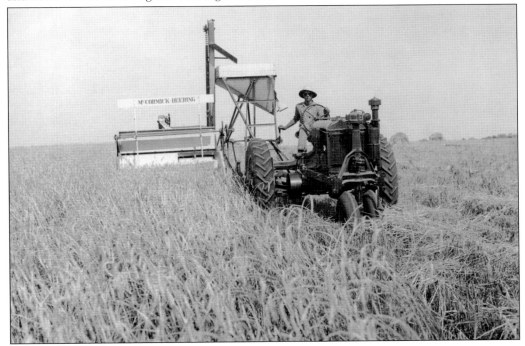

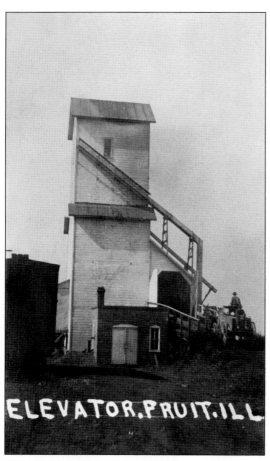

ELEVATOR. FRUIT. ILL.

John A. Fruit was the proprietor of the grain elevator (left) and the general merchandise store (below) at Fruit in Pin Oak Township. He was born May 29, 1862, and farmed with his father until 1882, when he opened his businesses. Since 1882, when the Nickel Plate Railroad was built, he was also the agent for that railroad. In 1885, he was made postmaster of Fruit and held that office until it was discontinued in 1935. John was also president of Edwardsville Creamery Company (ECCO) and A&B Feed Company in Edwardsville. He married Lilly Dzengolewski on September 18, 1901.

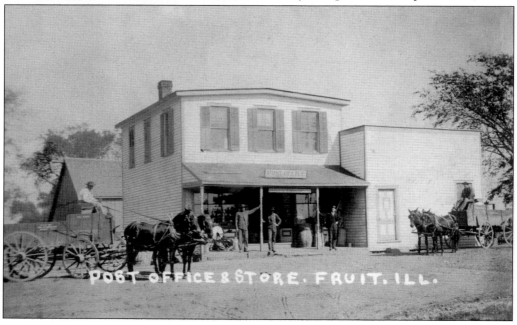

POST OFFICE & STORE. FRUIT. ILL.

This is the interior of the blacksmith shop of William Geers located on South Duncan Street in Marine. He is shown sharpening a plow shear on his large anvil in front of his brick forge. Marine was settled in 1817 by former sea captains. One of them, Capt. Curtis Blakeman, built the first mill in 1823. By 1882, Marine boasted over 40 businesses and professionals.

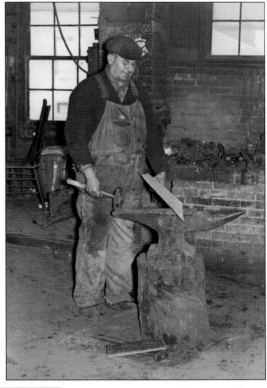

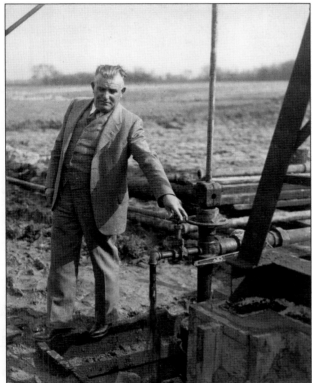

Ben Hess is shown here drawing oil from a spigot at one of several wells on his farm northeast of Marine. Oil production was heavy on the Hess farm, and a series of four tanks for handling the oil and another to remove the water were installed. Oil was discovered near St. Jacob in May 1942 and near Marine in May 1943.

Edwards Coles left his family's plantation in Virginia with slaves given to him by his father. While on the Ohio River on July 4, 1819, he freed his slaves. Upon arriving in Madison County, he gave land in Pin Oak Township to each of them who was the head of a household. Coles was a vigorous fighter of slavery and was instrumental in the 1824 defeat of the request brought by pro-slavery advocates for an Illinois constitutional convention. His enemies brought a suit against him in 1825 in Madison County courts, citing an obscure law requiring bonds to be paid for each slave that he freed. Coles was found guilty, but was exonerated by the Illinois Supreme Court. He left Illinois in 1832 but retained his land holdings in Pin Oak Township.

Eight

NAMEOKI, VENICE, AND GRANITE CITY TOWNSHIPS

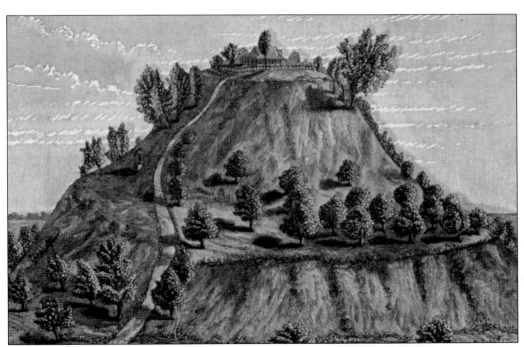

The 1882 *History of Madison County* includes this sketch of Monks Mound with an extensive explanation of the Cahokia Mounds area and artifacts. The state of Illinois purchased many of the mounds and created the Cahokia Mounds State Historic Site. In 1982, the United Nations Educational, Scientific, and Cultural Organization (UNESCO) designated Cahokia Mounds a World Heritage Site for its importance to our understanding of the prehistory of North America.

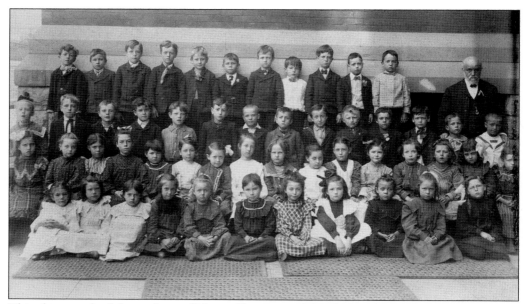

This photograph of the students of Venice Elementary School was taken in the early 1900s. The only student identified is Raymond Barr, in the center of the top row. The first brick school was built in Venice in 1868. It was two stories with two large rooms on the first floor and a hall on the second floor. In 1890, a front addition was built.

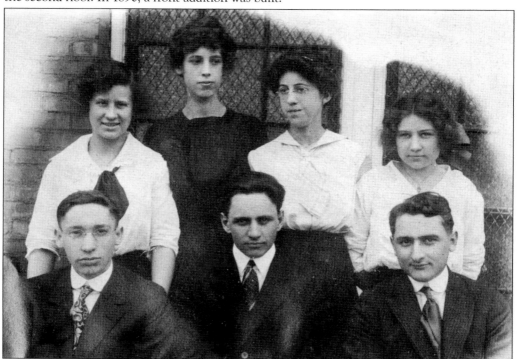

This is the graduating class of Madison High School about 1915, according to a note written on the back of this photograph. The names of the graduates as listed on the back are Ruth Beardsley Champion, Tillie Erickson, Frieda Michaels, Loretta DeLong Reiske, Jake Schermer, Ray Runkle, and Manny Ornists.

In the early 1900s, the Granite City area had a large population of Welsh immigrants, with many of them working at Granite City Steel. The St. David's Benevolent and Choral Society was organized, and an *eisteddfod*, a formal contest of singers, orators, musicians, and elocutionists, was held annually. Shown here is the St. David's Quartet.

The First Presbyterian Church in Madison was the first church in that town. Tragedy struck in 1924, when the church burned to the ground. A cornerstone for a new church was laid in 1925, and the building was completed in 1926. The year 1925 was a busy one for construction in Madison, with a new brick school built at St. Mark's Roman Catholic Church and the paving of Fourth and Fifth Streets.

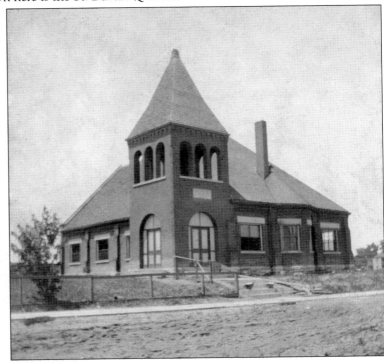

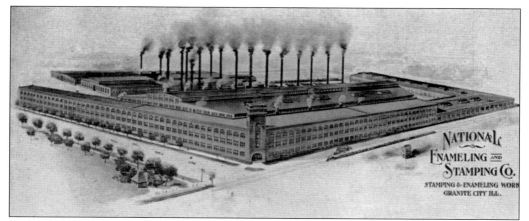

Frederick and William Niedringhaus began moving their graniteware factory to Illinois in 1895. They incorporated Granite City in March 1896. The business, called National Enameling and Stamping Company (NESCO), produced household and kitchen utensils that were sold worldwide. This image of the NESCO factory is from a promotional booklet produced in 1904, probably for the St. Louis World's Fair.

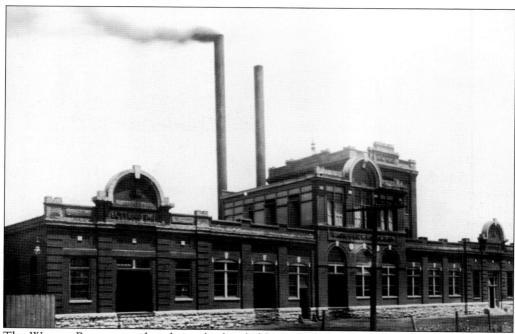

The Wagner Brewery produced popular bottled beers including the Muenchner, Granite, and Wagner brands in 1904. The brewery included a 50-ton ice-making plant. By 1908 it employed 250 people, making 50,000 barrels of beer annually. Prohibition ended beer production, but the brewery continued to make ice and also offered cold storage.

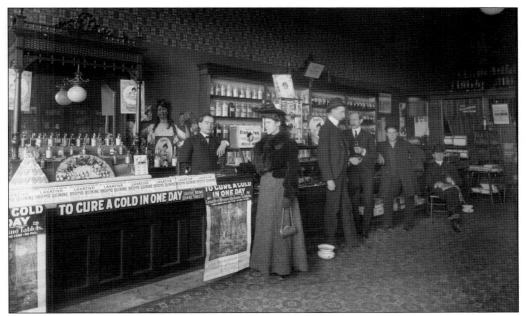

Guy House managed A.G. Schlueter's drugstore in Granite City from 1901 to 1904. He then purchased the business and added a fountain to sell ice cream, sodas, and fine candies. In this photograph Edna Reeves is standing at the counter, and Mr. Jackson, wearing the derby, is talking to Guy House.

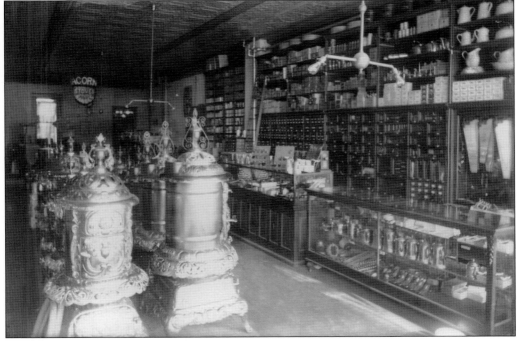

The Granite City firm of Childs and Anderson, shown here about 1910, sold everything a couple would need to set up a new home. Originally they sold jewelry, rugs, and curtains, but when they added a line of stoves and ranges in 1902, their business increased and they moved to a larger building and added furniture and other household furnishings.

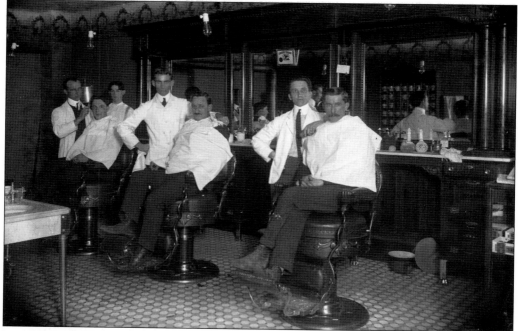

Mr. Miller and his barbers are pictured in his shop in Granite City. The shop included a bathhouse, where a man could get a bath for 10¢ if he washed his own back or 25¢ if he needed a back washer. A heavy curtain separated the barbershop and bathhouse. The young man standing in the background is the back washer.

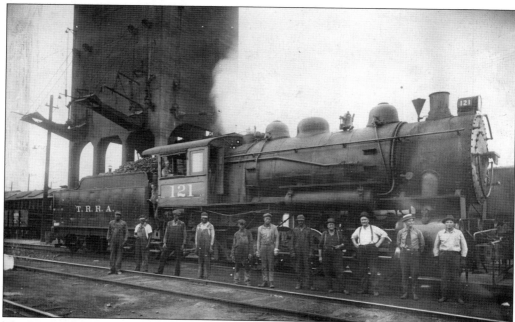

The Terminal Railroad Association (TRRA) was created in 1889 by a group of railroads to move freight and passengers across the Mississippi River between St. Louis, Missouri, on the west side and Illinois communities on the east side. This photograph, taken in the mid-1920s, shows workers at the TRRA's major yard in Madison, Illinois.

The St. Louis Syrup and Preserving Company established a plant in Granite City in 1903 to produce corn products, including syrups and starch. Corn Products Refining Company purchased the plant in 1907 and produced Karo Syrup. The plant was later owned by Temptor Corn Products, Union Starch, and Miles Laboratories. This image shows the aftermath of an explosion at the corn plant in August 1910.

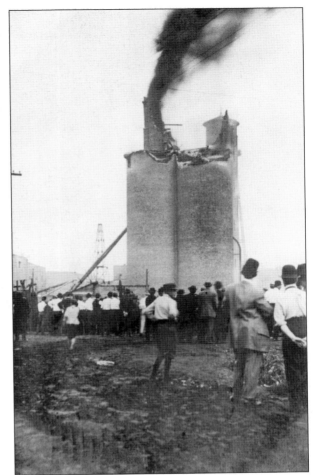

On May 18, 1923, ground was broken for the new Washington Theater in Granite City. The theater opened on December 21, 1923, with a capacity of 1,780 seats. It included a large lobby and dressing rooms under the stage. It was closed in the 1970s and was torn down to make way for a Madison County Transit Station.

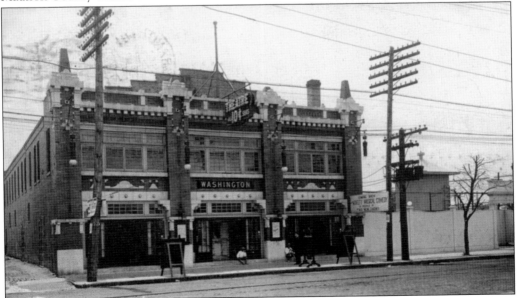

On November 2, 1925, two passenger trains collided on the Alton, Granite & St. Louis Traction Company line at Nameoki. Three employees were killed, and 28 passengers and one employee were injured. The Alton, Granite & St. Louis was an electric railway between St. Louis, Missouri, and Alton, Illinois.

This image shows excavations near Granite City in the late 1940s and early 1950s to construct Lock and Dam No. 27, along with an eight-mile canal to change the course of the Mississippi River and improve river traffic. Millions of yards of sand were removed down to bedrock. At that time, it was one of the largest excavations ever made in the United States.

The McKinley Bridge opened in 1910 to rail traffic only. It is located in Venice and situated south of the Merchants Bridge and north of the Eads Bridge. It was built with two tracks running through the superstructure. Auto traffic was added during the 1930s by hanging a single-lane roadway off of each side of the bridge. Rail traffic slowed down in the 1960s. At that time, one rail track was removed, and two auto lanes were installed inside the bridge superstructure. Rail traffic ended in 1987. The remaining rail line was eventually paved over. The bridge is named McKinley Bridge after William McKinley, the president of the Illinois Electric Traction Association, which built the bridge.

Resorts on Horseshoe Lake were popular in the early 1900s. Not only was the lake popular with fishermen (above) and duck hunters, but families came for picnics and entertainment, including sailing, swimming, dancing, and even riding a Ferris Wheel. The *Yellow Hammer* streetcar provided transportation with the guarantee of a "car every 10 minutes." William Moellenbrock built his resort on the eastern bank of Horseshoe Lake in 1875. The original building was destroyed by fire, and a larger one replaced it. It offered bowling alleys, shooting galleries, and fishing and other entertainment. According to an article in the 1895 industrial edition of the *Edwardsville Intelligencer,* "The best the market affords is served in both eatables and drinkables." The Horseshoe Lake Hotel (below) was another option available to visitors.

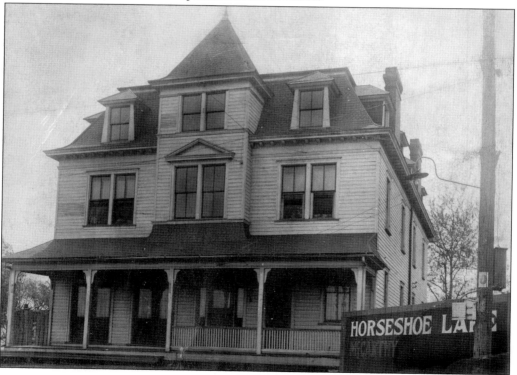

Better streets were demanded as Granite City grew. The improvements were made by leveling dirt roads using the same steam engines used in threshing, and then shoveling cinders over the roadbeds from wagons pulled by mules. While not up to today's standards for a paved street, it was a definite improvement over the mud and dust common with dirt roads.

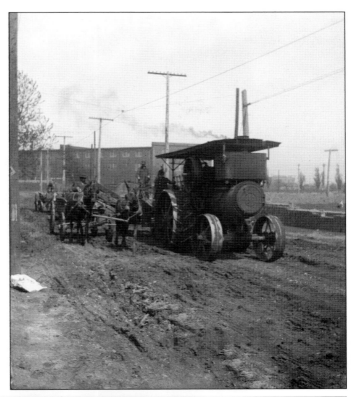

During World War II, meat was rationed and limited supplies were available. Fish was often eaten as a replacement. Near Stallings, residents took advantage of the floods in 1943 and the ready supply of fish. Several methods of fishing were used, including the drop nets shown here.

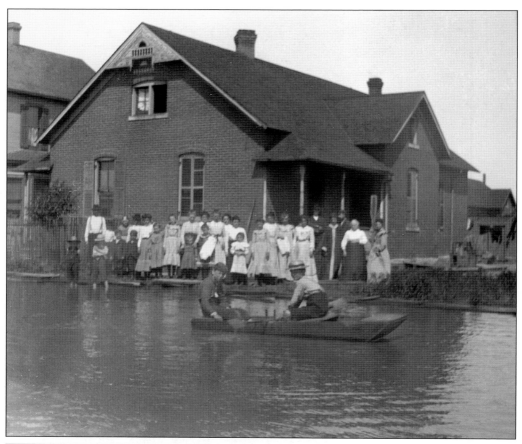

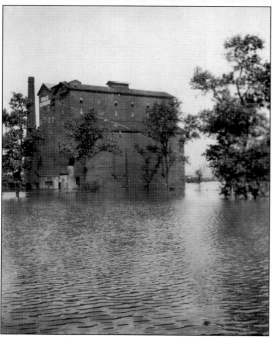

The flood of 1903 was disastrous in Granite City. On June 7, a levee broke north of Granite City and flooded West Granite City and Hungary Hollow, but was temporarily held back from the main area of Granite City by the high roadbeds of the railroad. The next day, water poured over the railroad tracks, stopping the trains and flooding the rest of the city. The photograph above shows the area from 1704 to 1706 Emerson under water. Like Granite City, the flood of 1903 was devastating to both Venice and Madison. All of the flooded communities rebuilt, a credit to the spirit of the residents. The photograph on the left shows the Venice elevator during the flood.

Nine

COLLINSVILLE TOWNSHIP

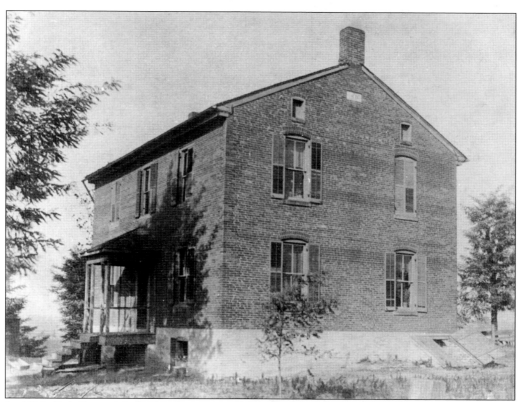

In 1808, Col. Samuel Judy, the first permanent settler in Madison County, built this home near Peters Station, pictured about 1910. It was the first brick structure in Madison County. The home was damaged by the New Madrid Earthquake in 1811, but was repaired. The small portals near the roof were created to enable the residents to repel Indian attacks. The house was razed in 1932.

Daniel Dove Collins (left) had started west from Maine in 1837. A carpenter by trade, he stopped to work on deepening the Erie Canal and then stayed in Chicago long enough to build a church before arriving in Collinsville in the 1840s. He was named Collinsville's first village president in 1850. He built the home below after he sold his brick, two-story residence to the Catholic church. The bricks for this spacious home were made on site. For a brief period around 1935 it was known as the Cedar Lawn Tourist Camp and was operated by a granddaughter, Florine Bowker. The house and property were eventually sold to the Veterans of Foreign Wars.

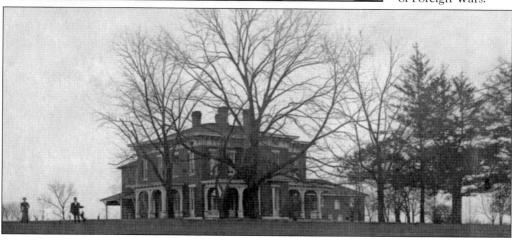

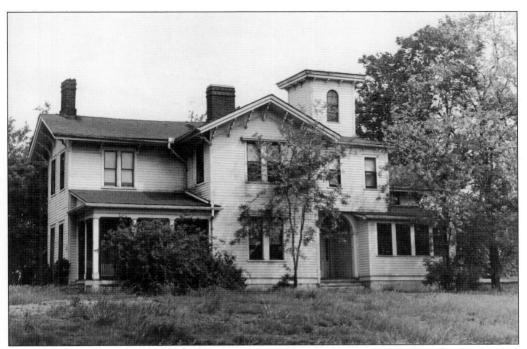

This home was designed for Dr. Henry Wing in 1865 and was a beautiful example of Italianate architecture. The Italianate style was the most popular design in the United States between 1860 and 1870. Two characteristics of the style seen here include decorative brackets under low-pitched roofs with wide, overhanging eaves and a square-shaped cupola or tower.

Although this postcard labels the building as the Gindler Hotel, it was better known as the Beidler Hotel. It was built in 1879 as the second home of Frederick and Angeline Beidler. It was located close to the depot and was an ideal place for travelers to buy a meal. The Beidlers operated it for many years and Angeline Beidler continued to operate it after her husband's death in 1904.

The Collinsville Fire Department began in 1872 with the organization of the I.C. Moore Enterprise Fire Department. The volunteers used a hand pumper donated by Mayor I.C. Moore. This 1935 photograph shows members of the Collinsville Fire Department posing in front of their equipment, including an Ahrens Fox pumper (left), a newly purchased Indiana Engine (center), and a fire department car. The Ahrens Fox pumper was purchased in 1925 at a cost of $12,450. Chief Robert Hartmann (center, wearing a white hat) started in the department as a volunteer in 1917 and served as fire chief from 1925 until 1947.

In May 1900, Collinsville residents saw the first streetcar travel over the Collinsville, Caseyville, and East St. Louis Electric Lines Railway. In 1905, Collinsville granted permission for the streetcar company to place all tracks in the center of the street. The streetcars became a major mode of transportation between towns, even fostering the Illinois Trolley Baseball League between Collinsville, Edwardsville, Alton, Staunton, Mt. Olive, and Virden.

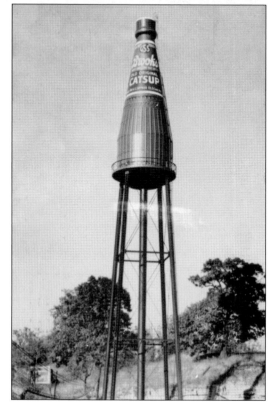

The farm fields surrounding Collinsville made food packing a big industry. The Brooks Catsup Company in Collinsville began in 1914. The company operated for many years, but dwindling supply along with other economic issues forced the sale and eventual closure of the business. The Brooks Catsup Bottle water tower remained as a local landmark and was refurbished in 1995.

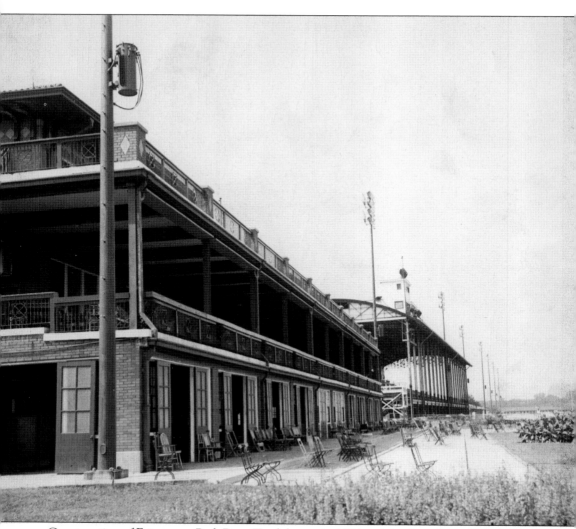

Construction of Fairmount Park Race Track began in 1924 with backing from Churchill Downs investors, which guaranteed financial security and gave the track respectability. It opened for horse racing in 1925 and held its first $25,000 Fairmount Derby in 1927. The Depression caused the end of the Derby in 1930 and times were hard for several years. The lights were added in 1947 and harness racing in 1948. Tornadoes damaged the grandstand in 1952 and 1953. The clubhouse and grandstand were destroyed by fire in 1974, and the races ran at Cahokia Downs until the rebuilt grandstand and clubhouse were opened in 1976. This undated photograph shows the Jockey Club in the foreground with the grandstand in the background.

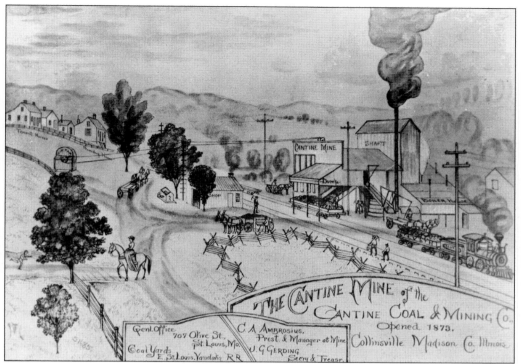

Coal mining was big business in Collinsville, with the first mine opened in 1859 by the Wonderly brothers. Several more mines followed, and during the heyday of the industry in 1921, the mines employed almost 1,800 men. The peak year for production was 1921, with 1,897,670 tons of coal mined. The Cantine Coal Mine (above) opened in 1873. This pen and ink sketch was owned by Samuel Cartwright, whose name is fourth in the second list of miners. The mine employed about 60 people, which was small compared to larger mines that employed 500 or more men. Lumaghi Mine No. 2 (below) was sunk in 1899 by Dr. Octavius Lumaghi. This photograph was taken sometime before World War II.

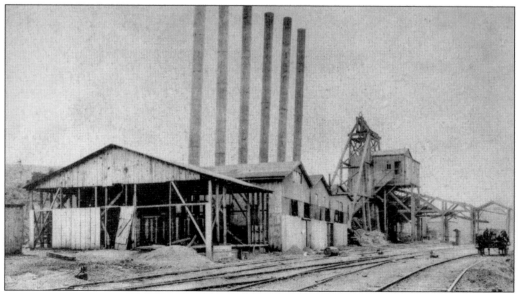

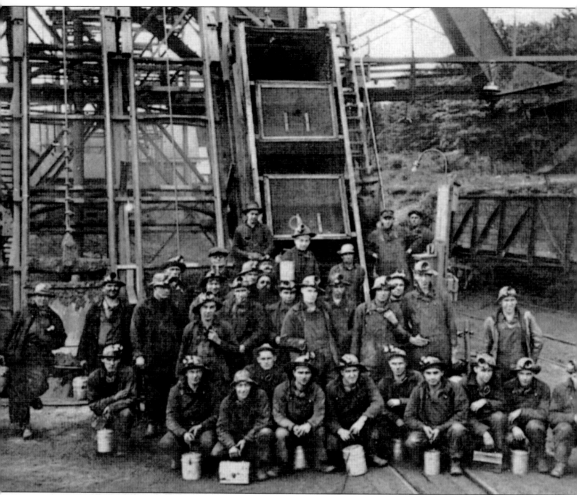

The coal mine was the reason for the birth, growth, and prosperity of Maryville in the early 1900s. The Donk Brothers Coal and Coke Company operated mines in Madison County at Donkville, Maryville, Troy, and Edwardsville. The shaft for their No. 2 mine at Maryville was sunk in 1900, two years before Maryville was incorporated. By 1910, the mine was ranked number 23 in tonnage among the 886 Illinois mines. Donk Brothers and Maryville worked well together in the over 20 years the mine operated. But eventually the coal ran out, and the mine was closed in February 1925. Here, a group of miners prepare to begin their shift.

The 1928 photograph above shows the Collinsville City Hall on the left and the fire station on the right. The Civil War memorial stands between the two buildings. The cannon near the corner of city hall, from the Spanish-American War, was sold for scrap during World War II. The Civil War memorial (right) was dedicated in June 1926. The inscription reads: "Erected to the Memory of Civil War Veterans 1861–1865 by Tent No. 19 Daughters of Union Veterans." The memorial is now on the other side of city hall. Among the Civil War veterans buried in Collinsville is Congressional Medal of Honor winner Nineveh S. McKeen, who is buried at Glenwood Cemetery.

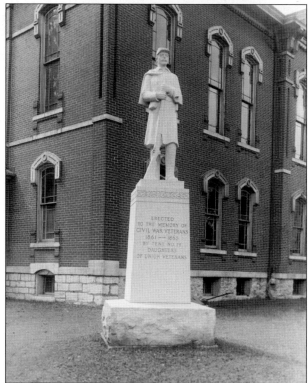

The Collinsville Memorial Public Library began operations on the second floor of the city hall with 121 donated volumes. The next move was to the Stumpf house on the corner of Church and Clinton Streets, and then to the second floor of the Miners Institute. In August 1923, the library was officially named the Collinsville Memorial Library to honor the "Soldiers from Collinsville who fell in the late war" (World War I). The library purchased the Look house (above) on West Main Street in 1927. Ten years passed in this facility, and then the center portion (below) of the current building was constructed; it opened in August 1937. An east wing was added in 1963, a west wing in 1967, and more recently, a four-floor addition was placed behind the central part of the library.

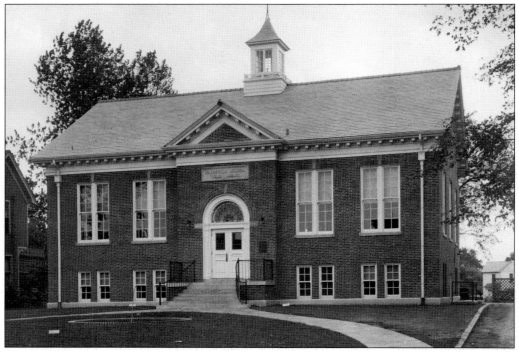

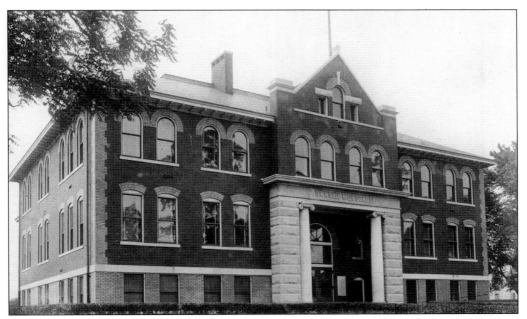

The Collinsville Township High School, built in 1908, was located on Vandalia Street. As needs changed and the school population increased, additions were made including a third floor, a gymnasium, and a shop wing. Across Vandalia Street were the band building, football field, and baseball diamond. Today, the building houses the Collinsville Christian Academy.

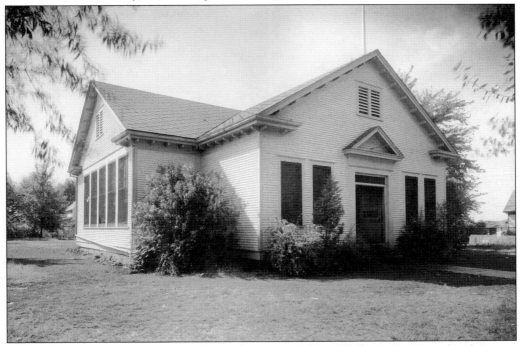

Donkville was a coal mining area located in section 22 of Collinsville Township between Collinsville and Maryville. The Donk Brothers Coal and Coke Company built the Cuba Mine in this area before 1900. The company built 50 frame houses for the miners. The area is now part of the city of Collinsville. This undated photograph shows the Donkville School.

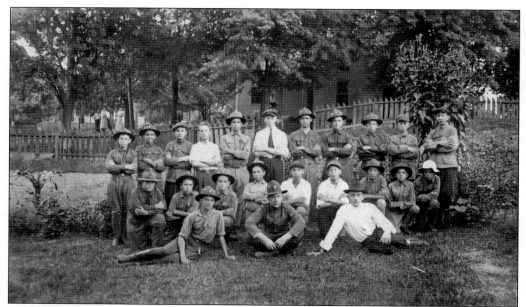

This undated photograph shows Collinsville Boy Scout troop no. 1. The only ones identified are scoutmaster William Paul, assistant Earle Haddick, senior patrol leader V. Siegel, and patrol leaders L. Larremore, H. Riles, and G. Ballard. Patrol leaders are elected by members of the troop to serve a leadership role. Lord Baden-Powell, the Boy Scouts founder, felt the patrol system should always be used by Scout troops.

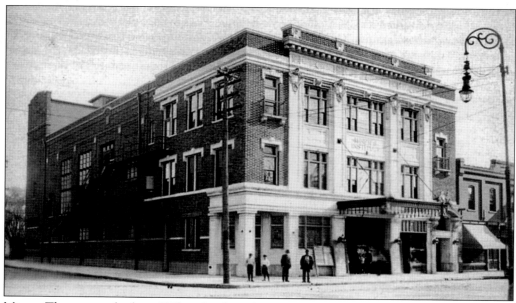

Miners Theater was built in 1918 with a loan from the United Mine Workers of America. The miners pledged one percent from their wages to repay the loan. The building included a theater, meeting rooms on the second floor, and a large banquet hall on the third floor. The dedication ceremonies in December 1918 included vaudeville acts and musicians from the St. Louis Symphony. (Courtesy of Collinsville Historical Museum.)

In 1915, the Old Settlers Union made a motion to organize a "historical society for the purpose of collecting relics and valuable information of all kinds pertaining to the history of Madison County." The Madison County Historical Society was formally organized in 1916 but remained inactive until 1922, when the new charter aimed to "stimulate a general interest in the history of Madison County; to encourage historical research and investigation; to collect and preserve all forms of data bearing upon the history of Madison County." In 1923, the Madison County Board of Supervisors set aside the courthouse's grand jury room for the society's historical collections. This was the beginning of the Madison County Historical Museum and Archival Library. In 1963, the society purchased the Weir house at 715 North Main Street in Edwardsville. After restoration of the house, the collection was moved from the courthouse, and the museum opened in the Weir house on November 1, 1964. The collecting of artifacts, documents, and books continued, and dedicated members of the historical society's board of directors, along with staff, volunteers, and the Friends of the Museum continued to organize and care for the collections, give tours, and sponsor special events. A need for additional space resulted in the building of a separate archival library adjacent to the Weir house. The one-story library building, dedicated March 3, 2002, was made possible through state grants secured by Illinois state senator Evelyn Bowles and fundraising efforts of the society. The complex now became known as the Madison County Historical Museum and Archival Library. The museum and library are located at 715 North Main Street in Edwardsville and are free and open to the public. Museum staff and volunteers provide guided tours of the eight rooms and basement of the Weir House and care for the collection of artifacts. At the archival library, the staff and volunteers assist researchers while working to preserve the collection of books, papers, maps, and photographs.

Discover Thousands of Local History Books
Featuring Millions of Vintage Images

Arcadia Publishing, the leading local history publisher in the United States, is committed to making history accessible and meaningful through publishing books that celebrate and preserve the heritage of America's people and places.

Find more books like this at
www.arcadiapublishing.com

Search for your hometown history, your old stomping grounds, and even your favorite sports team.